# majorca

## cooking and gastronomy

D0551968

Photography Oriol Aleu
Cooking and design Ana Torróntegui
Text Marga Font
Graphic design and page layout Joseta Torróntegui

TRIANGLE ▼ POSTALS

# cooking_mallorca

Acknowledgments:
Roger and Joana, Flavia, Toni Monné and Maria Torróntegui,
Oriol Casanovas, Toni Miquel, Cati, Ca'n Tià Taleca, Eduardo
Sardà of the Association for the promotion of Majorcan Almonds,
Bárbara from Bodegas Jaume Mesquida, Pere Picó from Olis
Sóller, IGP Ensaïmada de Mallorca, Miquel de Forn from Sa
Pelleteria, Associació de Pastissers i Forners, Ana Maria Victoria
from Melmelades i confitures Asanideso, Sebastià from Embotits
Obrador, Bartomeu of Embotits Aguiló, Jaume Clar from
Es Rafal, Melchor Lladó Mayol "Zion", Miquel from Formatges
s'Atalaia, Jaume from Formatges Burguera, Vi d.o. Pla i Llevant,
Vi d.o. Binissalem, Bernat from Cala Ratjada fisherman's guild,
Cristina from IGP Sobrassada Mallorca.

Product coordination and editing: Oriol Aleu
Cooking, planning, adaptation and revision of recipes:
Ana Torróntegui
Text: Marga Font
Graphic design and page layout: Joseta Torróntegui
Culinary advisor: Ada Pascual
Cooking assistants: Toni Miquel y Oriol Casanoves
Photographic production: Oriol Casanoves
Photography: Oriol Aleu

First edition in Spanish 2007

ISBN: 978-84-8478-269-8
Legal deposit: B-20.844-2007

Printing: Aleu, S.A.
Llull 48-52, Barcelona

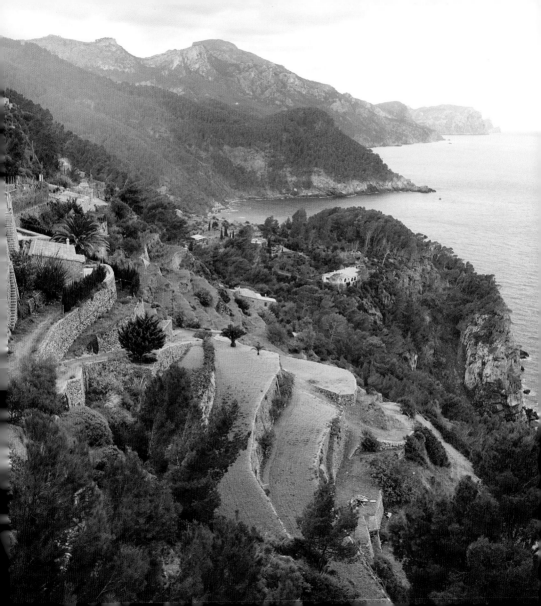

Taking a closer look at a region's gastronomy is in a sense a type of journey, a means of discovering new geographies through the dishes created from the flavours of the earth and sea. In this book on Majorcan gastronomy the reader will not only find information on products which are already known to be symbolic of this island, such as sobrassada, ensaïmada and almonds but also on other products, not so well known but also fundamental to this island's gastronomy, such as olive oil and honey or liquors such as hierbas and palo.

Majorcan cooking is a the result of a fusion between available foodstuffs and the gastronomic heritage of those people who, for one reason or another have passed this way, such as the Romans, Jews, Arabs and Catalans. Aside from these factors we also have to add that of creativity, driven by the need to eat, the desire to enjoy doing so and the isolation in which the Majorcan people lived prior to the bridges of communication being established with other lands. The book is completed by a selection of the most typical recipes. We could almost say a guided tour through the authentic flavours of this island. Have a good trip and enjoy your meal.

# The Majorcan table

"Its almost always the people with imagination who eat the best, perhaps because, as said by the Count of Clermont-Tonnerre, they associate the land's sustenance with the place itself, and get right to the core of the link which tethers them to this earth which supports them, establishing the secret essence of that with which they are united and thus shared with their lands in a feast of devotion".

These words from Galician gastronomist Álvaro Cunqueiro illustrate the important relation between creativity and the availability of food

In spite of the island's dependence on tourism, traditional agriculture is still alive and well. On the right, a view of Capdepera.

products. Without imagination humanity would have never advanced, our very survival having depended on it and, without imagination, neither would what we understand to be gastronomy exist as we know it today.

On the basis of this correlation, it can be said that Majorcan gastronomy is both rich and inspired, created as it is with fresh produce from the land and sea. The traditional rural society, with a precarious subsistence economy before the influx of tourism, has literally made the most of all available food produce, having converted animals, such as pigs, and trees, such as the fig, into veritable benefactors for the local stomach.

The island's gastronomy is a perfect example of having adapted to the environment and a passing encounter with different cultures and the cultural heritage they left behind. Offerings from the island itself include soups (vegetable and at times meat with finely sliced brown bread), *l'arròs brut* (a soggy rice dish prepared in days gone by with whatever meat and ingredients were available) or *frit de matances* (a hearty combination of various pork cuts with vegetables and spices). But there are also Catalan contributions which are now considered to be part of the island's anthropological

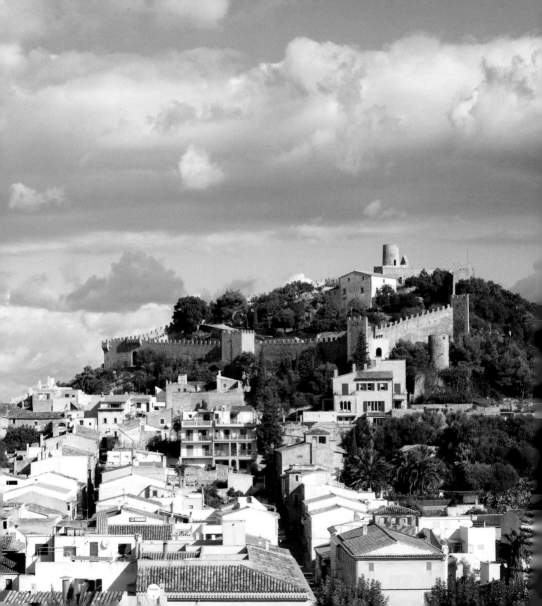

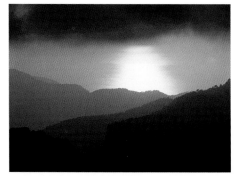

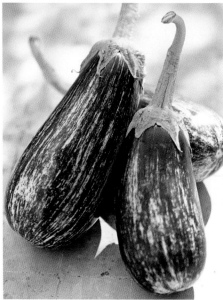

heritage, such as *sofrits*, *picadas*, used to enrich stews or *all i oli*, whilst Arabic and Jewish legacies are manifested in the taste for lamb and the sweet pastries such as ensaïmada and finally dishes of Mediterranean origin which give rise to such delights as *tombet* (fried potato, aubergine, and red pepper), rich fish dishes or *embutits* (types of sausages cured or otherwise) such as the *sobrassada*.

Until the great influx of tourism, agriculture, fishing and livestock farming were the main activities on Majorca. Being an island, the need to be self sufficient meant they had to make the most of natural resources which meant an increase in the cultivation of such as cereals, wine and olive trees. This insular self-sufficient world remained completely unchanged until the mid 19th century, when maritime transport became regulated. Later, in the 20th century, changes to the most predominant crops were brought about by the introduction of new water extracting techniques which significantly improved irrigation.

In more recent decades, the land and the workforce have had to face up to the fact that traditional activities, such as agriculture, livestock farming and fishing have been relegated to second or even third place. That said, this island still hasn't

Majorcan gastronomy is based on fresh produce from both the land and sea.

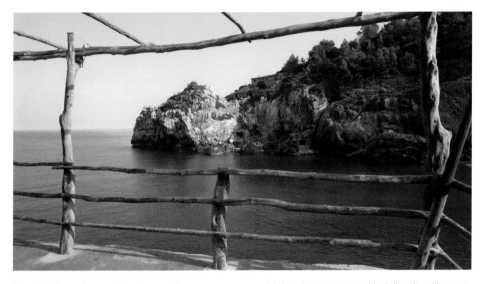

forgotten its gastronomic heritage and some young farmers have opted to modernise their farming methods and adapt traditional products to meet the current demand for quality food produce. Products are now produced which are protected by various quality assurances, such as the wines of Binissalem and those of Pla i Llevant, awarded and protected by the Designation of Origin which certifies that a product comes from a particular region and conforms to certain quality standards.

Majorca's great geographical diversity with mountains and plains, hidden valleys and woodlands, dry and irrigated lands, establishes the existence of differentiated terrains and microclimates which promote the development of many different types of cultivation and livestock farming. The sea, on the other hand, provides for the freshest of fish and seafood. The dishes prepared on the island, fruit of the gastronomic expertise of generations of Majorcans, give the fresh produce from the land and sea a certain added value.

The finest fresh fish and shellfish dishes are to be enjoyed in places such as Cala Deià.

# The Serra de Tramuntana

The Serra de Tramuntana is the most rugged part of the island predominated by olive cultivation and sheep rearing. The Tramuntana mountain range forms the backbone of the northeast of Majorca and represents an area of almost one hundred kilometres which extends across eighteen municipalities or towns of which the largest are Calvià, Pollensa and Escorca. Various summits have above a thousand metres altitude including Galatzó (1.026 m), Teix (1.064 m), Massanella (1.348 m) and the highest of all, Puig Major (1.443 m).

This is a rugged and at first sight hostile region which has changed considerably since the onset of mass tourism.

The organisation of the mountain terrain had until that time been based around possessions, large farms which influenced both the landscape and the local economy. The active population depended on work from these "*fincas*" or farms, above all when the time came to harvest the cereals and olives and, the rest of the year they would be cultivating small plots of land or making use of the forest's resources for

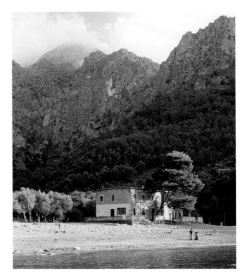

The Tramuntana Mountains encompass some of the most impressive landscapes on the island, such as Cala Tuent or Formentor.

such as charcoal or lime production, or collecting firewood.

For centuries the main source of income for the mountain based possessions was olive oil which was exported in large quantities to other European destinations such as Italy, France and Holland. Olive oil production came to be very important to the island to the extent that, in 1784, there were as many as five hundred olive oil mills. These mills employed many workers. Hundreds of women from other districts

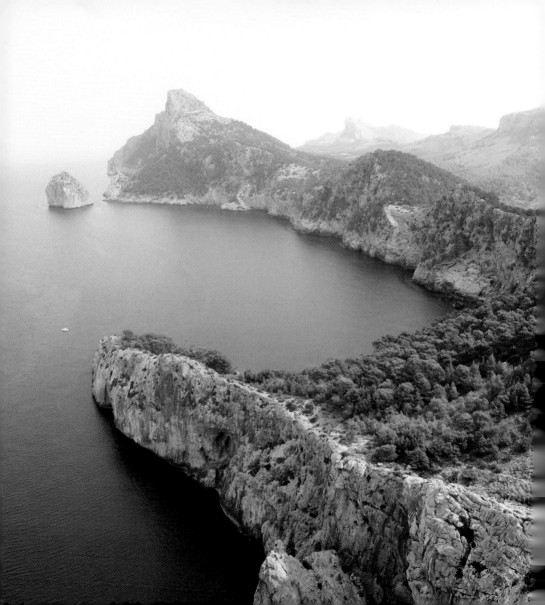

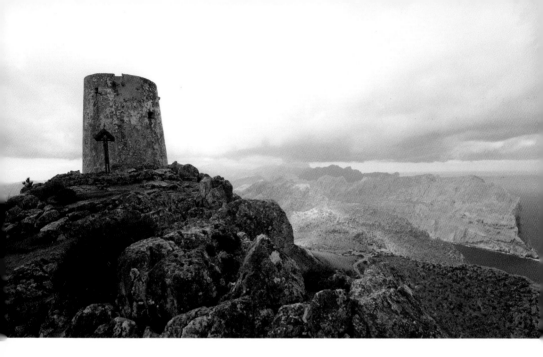

came to the mountains to collect olives during the harvesting season whilst the men took care of the oil mill for the oil production.

Other traditional activities, also of fundamental importance, included wood gathering, acquiring fodder for the livestock and hunting, above all thrush. The production of charcoal and lime as well as snow collecting are activities which have also left an important anthropological legacy, something still visible from some of the mountain roads.

The entire coastline is dotted with watch towers, such as the one at Formentor, which served to warn of the arrival of pirates.

The latter activities were an important addition to the economy of many households. Charcoal production was usually carried out in spring and summer and often involved the entire family participating. Firstly the wood had to be chopped, whether it was Holm oak, pine or other trees and bushes, after which it had to be stacked and covered with slender green branches. The wood was finally set alight and burned slowly. Later the charcoal was selected and taken to towns or to Palma to be sold.

The abundance of chalky stone also made it possible to produce significant amounts of lime, used in construction, supplied to people with a recognised calcium deficiency and also used to insulate houses and to disinfect cisterns. Another important resource was the snow which, in bygone times, was a product with both medicinal and gastronomic properties. Snow was collected and stored in snow houses (*cases de neu*), which were actually holes dug in the ground with dry stone walls and a paved floor.

One of the landscapes most typical of the mountains is that of the horizontal terraces painstakingly cut into the mountainside to gain land for cultivation and which also help to retain the rainwater. These terraces, delineated by dry stone walls, were usually used to plant olive, almond and carob trees.

Nowadays the cultivated areas are mostly the valleys which are occupied by the irrigated lands of Soller, inundated with citrus trees, Pollensa and the terraces of Banyalbufar, Estellencs and Deià. The crops most typically found on the dry un-irrigated lands continue to be the olive trees, at times combined with cereals and carob trees. The olive oil produced from the fruit of these olive trees is sweet and of an excellent quality.

Mountain villages, such as Deià, have seduced many artists and intellectuals. Below, a view of Puig Major.

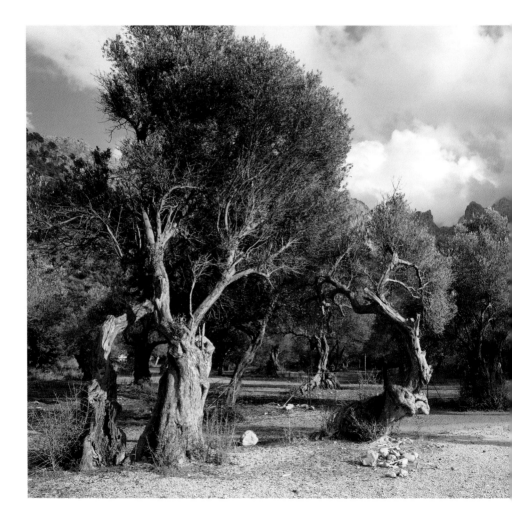

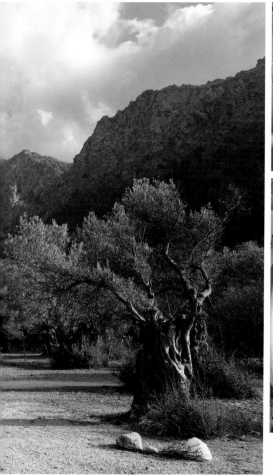

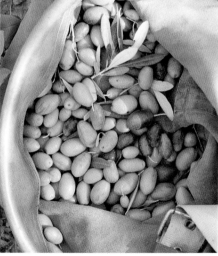

Mountain lands and terraces are filled with olive trees, the fruit of which is used to make a most exquisite sweet olive oil.

# Es Pla,
## agricultural plains

Es Pla is the island's most central region, which includes the majority of the cultivated terrain. These are fertile lands divided up into fields with cereal crops, carob, almond, fig and apricot trees. Produce also includes excellent fruit and vegetables such as artichokes, aubergines, melons and watermelons. The Pla de Sant Jordi area, close to Palma, is predominated by livestock fodder and greenhouse cultivation, mostly lettuce and tomatoes.

Many *fincas* or farms are also now reclaiming the vineyards and consequently reviving the wine production.

This region covers the central depression between Majorca's two main mountain ranges: the Sierra de Tramontana and the Sierra de Llevant. Included in this region are the towns of Algaida, Ariany, Costitx, Lloret de Vistalegre, Llubí, Maria, Montuïri, Petra, Porreres, Sant Joan, Santa Eugènia, Sencelles, Sineu and Vilafranca de Bonany. In all, this expanse of lowland covers some 600 km2. The climate here is marked by very dry summers and cold damp winters, the rainfall mainly confined to

The almond tree is one of the main cultivations in the Es Pla region. Although now redundant, windmills still form a part of the district's landscape.

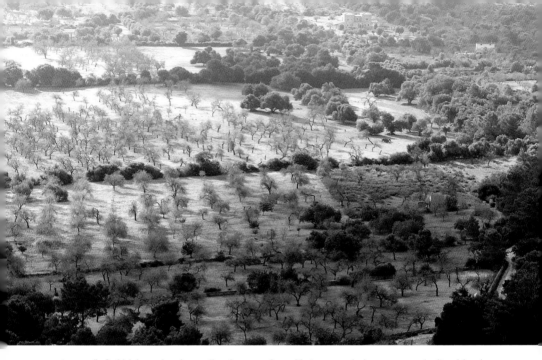

autumn, all of which has a bearing on the absence of water courses and which originally made irrigated agriculture impossible. For generations the crops which were cultivated in Es Pla were suitable for un-irrigated lands, most of all cereals which supplied the entire island.

Majorca's inland towns have various features in common, starting from their appearance: stone built houses clustered around a church, together with the odd monastery. And all surrounded by fields dotted with trees and sheep, an agricultural landscape transformed by mankind and still at one with nature. Earth and stone.

The landscape of Es Pla has been sculptured by traditional agriculture and even though, with the advent of tourism, this suffered a serious setback, there still remains architectural evidence which now represents an enormous cultural and ethnological heritage. Flour mills, for example, are to be seen in abundance, many now converted into homes, also

Almonds are cultivated in Es Pla, as are the grapes which are used to make excellent wines, and the peppers which are left to dry in the sun.

constructions designed to make the most of water, such as wells, water wheels and cisterns, some, also bearing a strong lexical heritage, of Muslim origin. And of course, as is the case throughout the island, the possessions, large farms and agricultural holdings where the population from surrounding areas were usually employed on a temporary basis. Literally everything which related to agriculture and livestock farming was carried out within these boundaries, and their large mansion type houses which integrated perfectly with the landscape and are fine examples of the local architecture.

Every town in the Es Pla region holds a weekly open air market where the local farmers sell their fruit and vegetable crops as well as the *embutits*, cheeses and crafts. The most important is without doubt the market which is held in Sineu every Wednesday morning which was originally established by king Jaume II in 1306. Here they also sell live animals, indigenous to the island, and the regions farmers and stockbreeders turn up very early to make their purchases. In passing, they breakfast on a spicy frit (potatoes, vegetables and either lamb or pork, all chopped and spiced) with a glass of wine in one of the popular "cellers", former bodegas now converted into restaurants serving traditional cuisine.

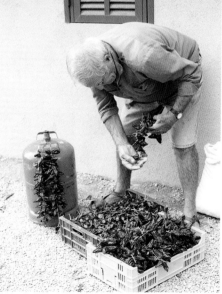

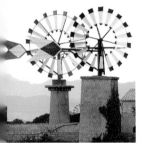

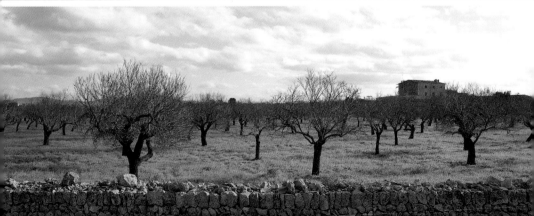

Also, one of the island's oldest and busiest fairs is held in Sineu on the first Sunday in May, a privilege granted by King Sancho in 1318. Activities include such as Majorcan sheep dog trials and black pig auctions, a breed indigenous to the island. And every second Sunday in December, the town plays host to the *Fira de Sant Tomàs*, (St. Tomas fair) which promotes the leading product produced from traditional farm-slaughtered pigs, the *sobrassada*.

Other traditional fairs and markets in the Pla region dedicated to the earth's produce include the Melon market in Vilafranca de Bonany, the Honey market in Llubí, the Partridge fair in Montuïri and the *Fira de Santa Eugènia*, a competition with fowls indigenous to the Balearic Islands.

**Raiguer, Llevant and Migjorn.** Raiguer is the transitional zone between Es Pla and Serra, the agricultural and industrial region symbolized by huge fertile sloping lands upon which carob, olive and almond trees were traditionally cultivated. Nowadays however the most encouraged and prosperous farming is that of the vineyards, with excellent wines being produced in this area and which bear the Binissalem Designation of Origin The busiest weekly market is the one held on Thursday mornings in Inca and some other festivals worthy of mention include the

The inland towns and villages have preserved their traditions and their cookery has been passed down through the generations.

*Fira des Veremar* (the grape harvest festival) and the wine festival in Binissalem, the *Esclata-sang* (saffron milk cap mushroom) at Mancor de la Vall and that of the *Vi Novell* (young wines) at Santa Maria del Camí.

Sheep breeding takes place in the Llevant and Migjorn districts, above in the Artà area, and pig breeding in Manacor and Felanitx. There is also a substantial production of fruit and vegetables in the municipality of Manacor such as tomatoes, melons, watermelons, lettuces and aubergines as well as local firms which make excellent *embutits* or sausages especially the *sobrassada*. In the last few years the wine and the production of wines bearing the Designation of Origin for Pla i Llevant have acquired great importance. Other important cultivations are almonds, cereals and fodder for the livestock in addition to which some excellent cheeses are produced with the milk from the cows, sheep and goats. Naturally the gastronomic fairs and festivals are also remarkable, above all that of the *Mostra de la Llampuga* (Llampuga being a local fish) held in Cala Ratjada (Capdepera) in September and la *Fira del Pebre Bord* (wild pepper) held in Felanitx, in October.

# The sea's delights

In Christian gastronomy, fish was considered to be a food of abstinence which symbolised purification, although French gastronomist Brillat-Savarin would have argued it had invigorating properties. In the old days it was a common foodstuff, in the derogatory sense of the word and surprisingly, in many of the old recipe books there was scarcely any mention of fish dishes.

Nowadays things have changed somewhat. Eating fresh fish and shellfish is a veritable luxury, even more so when some fishing zones are on the brink of collapse due to being over fished. Fishing is an activity of prime importance in Majorca and the island has a large fishing fleet added to which, many of the fish dishes served in the island's best restaurants are based on former fisherman's recipes.

The Balearic Island's fishing zone extends some 28.000 km$^2$ and the main fishing ports are Palma, Santanyí, Port d'Andratx, Sóller, Alcúdia and Cala Ratjada. The waters around these islands provide a great variety of fish, crustaceans and molluscs but some are worthy of special mention in account of their link with Majorcan gastronomy and tradition.

The most abundant shoreline fish are the so-called rockfish which include species used in stocks and soups and others which are excellent grilled or baked, such as scorpion fish (*escòrpora* in Catalan), red scorpion fish (*cap-roig*), gilt-head sea bream (*dorada*), saddled bream, painted comber (*serrà*) and the rainbow wrasse (*donzella*). Also abundant are some of the most popular Mediterranean varieties such as grouper (*anfós*), sea bream (*besuc*), red mullet (*moll de roca*) and white sea

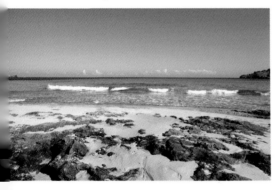

The coastline is a combination of cliffs, beaches and coves, such as Cala Agulla, and the towns are now almost entirely dedicated to tourism.

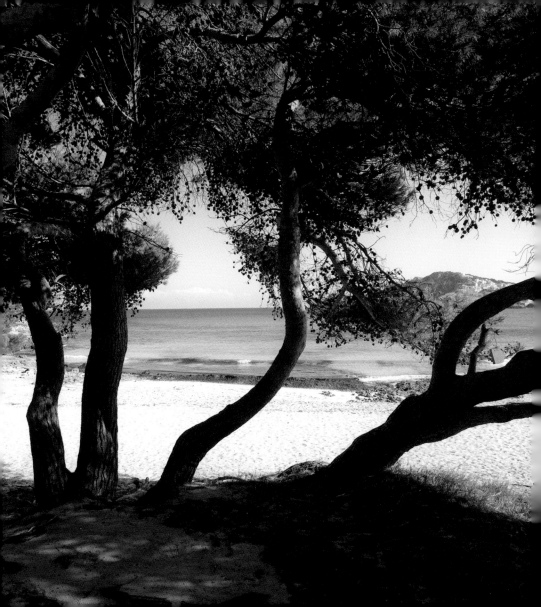

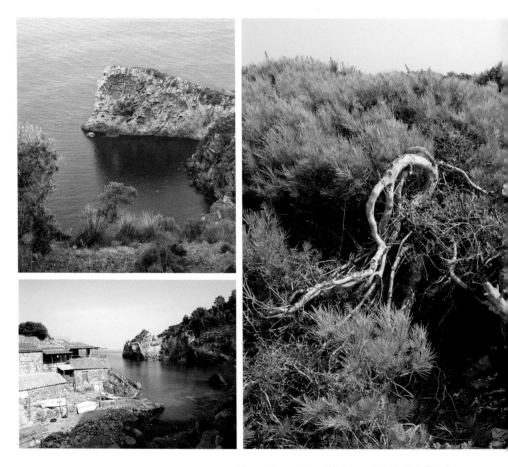

Some of the most beautiful places on the island: Sa Foradada (above), the mythical Cala Deià, (below) and the Ses Salines beach (right).

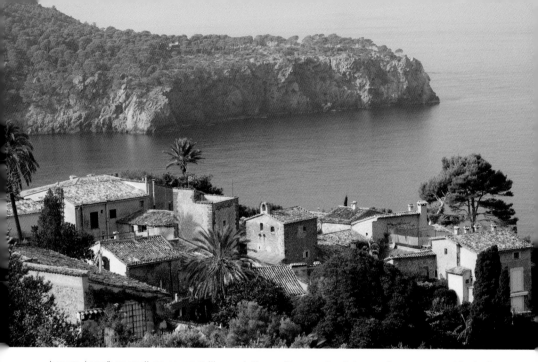

bream (*sard*) as well as serpent like varieties such as eels or the moray eel and flat fish such as the John Dory (*bruixa*).

Amongst those which live and are caught further offshore are some oily fishes such as sardine, mackerel, tuna, bonito, gilt sardine (*alatxa*), anchovy and black meagre (*escorball*). Not forgetting the swordfish or the rare but well appreciated dolphin fish which appears in Balearic waters at the back end of summer.

Llucalcari is a peaceful place which was once a favourite of British writer Robert Graves, the author of I, Claudius.

Deep water fish are also consumed including the shark family, protagonists of exquisite dishes such as the ray (*ratjada*), smoothhound (*mussola*) or dogfish (*gató*).

Aside from the fish varieties, cephalopods such as cuttlefish, squid and octopus have a very special place in the island's gastronomy, above all in rice dishes or stews with plenty of onion. And naturally there are the crustaceans such as red lobster, considered to be one of the

best in the Mediterranean, as well as various types of crabs, pink, red and white prawns, often just grilled with a little oil and sea salt.

Buying fresh fish in one of Palma's markets, such as the s'Olivar or the Santa Catalina, or in a fish market in one of the coastal towns, is virtually a ritual. As well as allowing us to know the origins of the product we are also able to eat it in season, when it's at its most affordable and the flavour is at its best. As for the pleasure of buying in the market, a quotation by famous chef Paul Bocuse says it all: "I go to the market every morning and take a walk around the stalls. Making the purchases personally I know, for example, that one particular farmer has some first rate cardoons, another specialises in spinach and another has arrived this morning with some delicious goat's cheese.

I often don't know what I will be putting on the menu: it depends on what I find in the market. This is, I believe, the secret to good cooking. It's a shame my contemporaries seem to be gradually losing track of the seasons and the traditional sense of ritual which comes with each one".

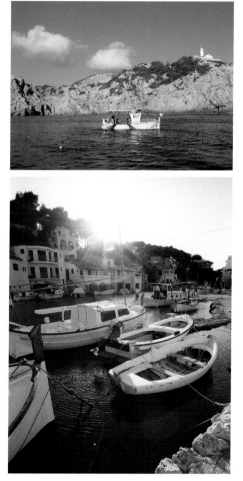

Capdepera (above) and Cala Figuera are two remaining fishing enclaves where it is still possible to watch the daily catch being unloaded.

Majorca's benign climate and fertile soil has provided it with a great variety of food produce which has been transformed, out of need and through imagination, into some exquisite products: *embutits* (sausage type products) such as *sobrassada* and *botifarró* and pastries as emblematic as the *ensaïmada*, in addition to a long list of both sweet and savoury baker's delights, virgin olive oils from the Tramontana mountains, liquors such as *palo* or *hierbas*, all types of conserves, almonds, honey, wines bearing the Designation of Origin. These excellent quality ingredients are brought together in the recipes of what is a very personal gastronomy which knowledgably combines the gifts from both land and sea.

# the island's
# produce

# The great benefactor

Pigs have been bred as domestic animals for some ten thousand years. Pig accounts for a quarter of the meat consumed throughout the world and is also a source of leather, soap, edible fats and hormones such as insulin. Practically the entire animal is put to use, a factor which has encouraged its breeding in rural communities such as Majorca.

For centuries the pig has been the great benefactor of Majorcan gastronomy, above all when this was a subsistence economy, in reality barely fifty years ago. At the time the rural calendar revolved around the slaughter of this animal, this being a time for celebration and stocking up the food supplies for the rest of the year.

It's difficult to imagine what either the Majorca of today or yesterday would be without the ubiquitous pig. There was and continues to be a *porcofilia* society, as is explained by Trías Mercant in his indispensable book *Antropologia de la cuina mallorquina* (The anthropology of Majorcan cookery): "According to anthropology (...) *porcofilia* involves family pig rearing and home cooking. The Balearic agricultural

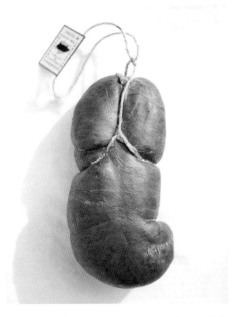

culture, one hundred percent porcofilia, carefully separated and isolated, as in a rite of passage, the pig from the slaughter and it was diligently fattened for the kill".

In Majorca, the indigenous breed of pig is the so-called black pig, bred in the wild in forest groves and scrubland. This animal accumulates a great deal of fat and at seven or eight months is taken to the pig-fattening farms and at eighteen – when it weighs around two hundred kilos – is duly slaughtered.

The meat from the black pig (*porc negre*) is protected by the mark of guarantee Porc Mallorquí Selecte (PMS).

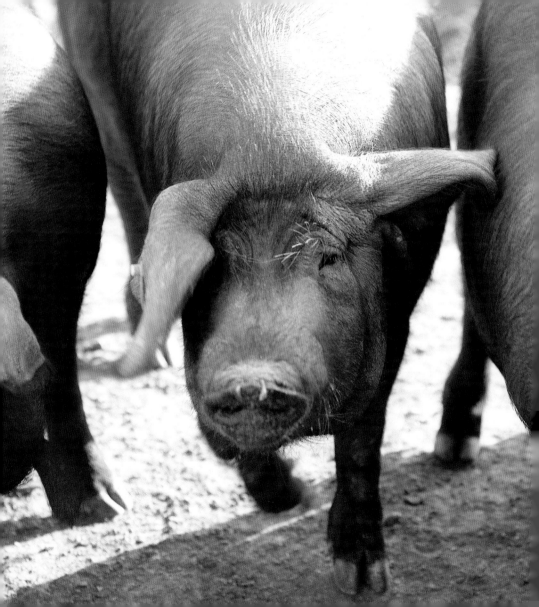

# An identity symbol

*Sobrassada* is literally one of Majorca's identity cards. Born of the necessity to preserve the pig's meat, there are those who maintain that its name comes from the Italian *soprassata* which also refers to another pork based sausage or *embutit*. It is made from raw meat without blood and cured

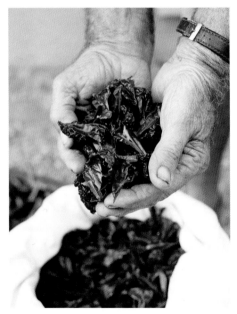

before being consumed. Known to have been in existence at least since the Middle Ages, it was transformed and improved with the arrival of paprika from the Americas which also gives it its distinctive colour. Since the seventeenth century, it has became one of the island's most representative food products.

It is without doubt the most appreciated product of the slaughter, the intestines selected and cleaned and any fat and imperfections removed to make the *embutits*. To make the *sobrassada* the best quality meat is selected, chopped and a little pork fat is added (*xulla*), all minced together to mix well with the rest of the ingredients: a generous amount of sweet paprika, cayenne pepper and salt to taste. The final well worked mixture, can be tasted raw or fried and has to be very tasty indeed.

Once made and tied, the *sobrassadas* are hung and their transformation begins: they lose moisture, the mass blends together and both the flavour and the red colour become more apparent. After a certain time they have their usual characteristic appearance, now cured and covered in a fine white powder created by fungus and yeast. The changes are not confined to the outside, the inside having changed too.

Dried red pepper made into paprika
is indispensable for making *sobrassada*.

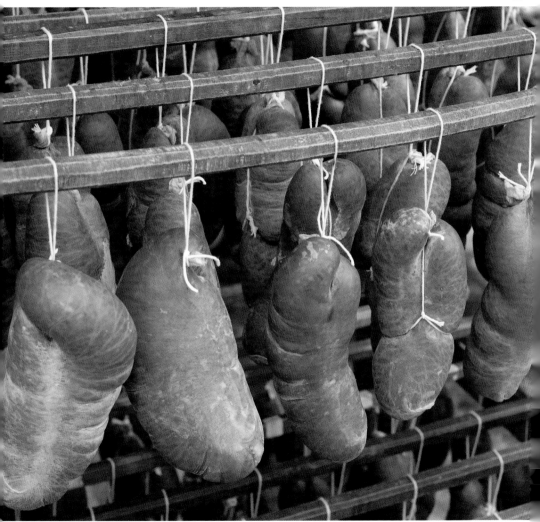

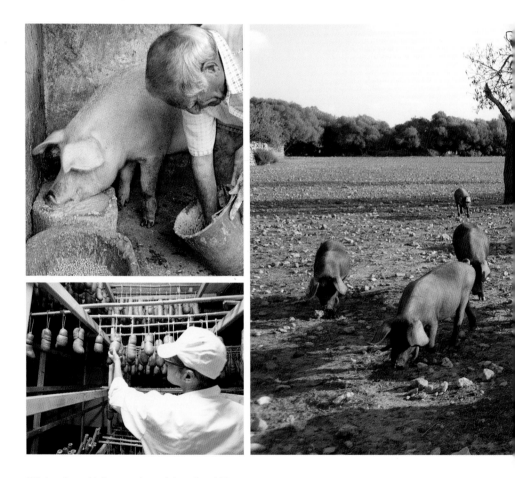

Little has changed in the way *sobrassada* is made and it has now been awarded a Protected Geographical Indication.

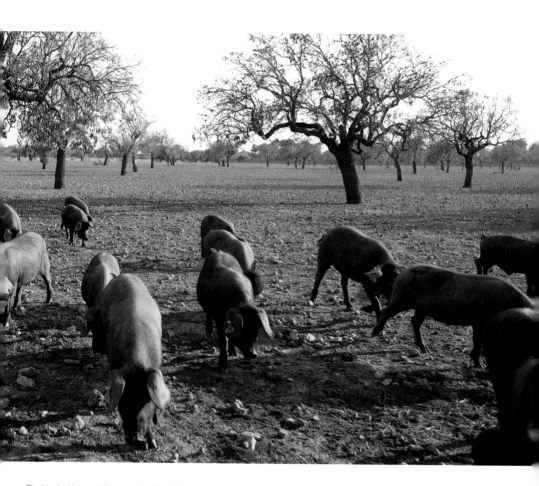

The black pig lives at liberty on the island's farms. It will be sacrificed at around eighteen months old, when it weighs some 200 kg.

# BREEDS

When it comes to pigs everything is used. The traditional embutits, made at the time of the slaughter, serve to make its meat available all year round. Now as in the past *sobrassada* continues to be the king of the island's *embutits* which go by various names on account of their shape and size. It was the first Spanish embutit to be awarded the Specific Designation of Origen before the European Union, in 1994, and two years later received the Protected Geographical Indication. The *Sobrassada de Mallorca* designation protects two types of this *embutit*, both of which must be produced on the island, without any artificial colourings, made exclusively with pork, paprika, salt, natural spices and flavourings: firstly the *Sobrassada de Mallorca* made with selected pig meats and secondly the *Sobrassada de Mallorca de Porc Negre*, made with pork from the black pig indigenous to the island. The product itself is tested and controlled by the *Consell Regulador de la Sobrassada de Mallorca* to ensure the pigs are pure-bred, fed naturally and live in the wild for at least a year.

The time it takes for *sobrassada* to mature varies with regards to its size and density.

*Embutits* and *sobrassadas* are generally made with the pig's entrails, the various parts corresponding to different products, notably the following:

**1** *Camaiot*. An exquisite and fairly fatty *embutit* made with pork rind from the leg or neck.

**2** *Botifarró*. A blood sausage type *embutit* and therefore with a short preservation time, eaten grilled, fried or added to stews.

**3** *Bisbe* (bishop). Made with the pig's stomach filled with *sobrassada*. Requires a longer time to mature than other parts and is therefore usually eaten in summer.

**4** *Culana*. A long fat *sobrassada* which is stuffed into the animal's rectum. Can measure up to fifty centimetres.

**5** *Llonganissa*. Made from *sobrassada* stuffed in the small intestine of the pig and often measures almost sixty centimetres. Can be eaten after only a week, grilled or fried.

**6** *Arrissada* (curled). This *sobrassada* is made with the pig's large intestine and can be eaten raw after a certain maturing period.

**7** *Bufeta*. Made with the pig's bladder and usually eaten in the summer months. It can weigh up to eight kilos.

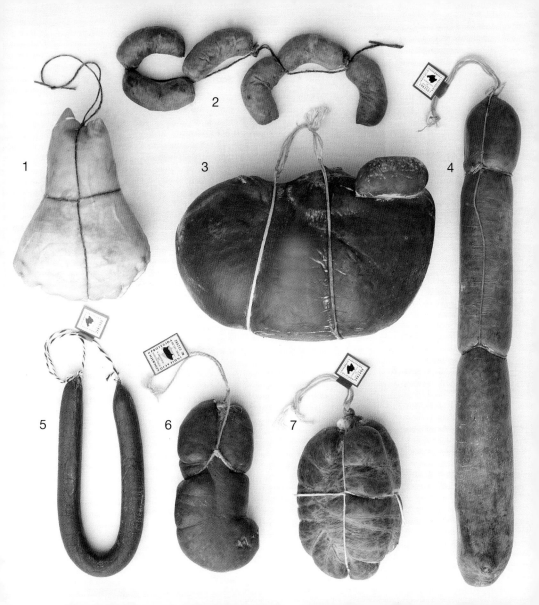

# In praise of the
## *ensaïmada*

"Just out of the oven, they appear shiny, golden and pleasing to the eye, like a symbol of peace" This was how Catalan painter and writer Santiago Russinyol expressed his feelings on the Majorcan *ensaïmada*, now awarded and protected by a *Specific Designation*, which guarantees its quality.

The *ensaïmada* is a circular cake created by coiled sweet pastry, made from flour, sugar, yeast,

eggs and lard (in Catalan *saïm*, from whence comes the name *ensaïmada*). The origin of the *ensaïmada* is uncertain. Some historians are of the opinion that its origins are Hebrew as, apparently, a Jewish pastry maker offered one to king Jaume I during the Majorcan conquest. Others believe it to be of Arab origin and in a Majorcan recipe book by Jaume Ferrà i Martorell some Arabic sweet pastries called *bulemes* dolces are described as coiled and made with the same ingredients as the *ensaïmada*, although the lard is replaced by butter made from sheep's milk. However, it also says in the same recipe book that in traditional Jewish cooking there are also desserts called *bulemes* and of the same coiled shape.

Whatever the case, its popularity both on and off the island is indisputable. *Ensaïmadas* today are still made according to the traditional recipe albeit now with a variety of fillings. The original ones probably weren't filled but later there appeared many tempting varieties: with *cabell d'ángel* (a preserve made of strands of pumpkin in syrup), with slices of *sobrassada* and pumpkin (typical of Carnival time) or apricot, confectioner's custard, cream, *turró* (similar to nougat), chocolate or almond.

The island has an abundance of bakeries and cake shops with a profusion of local delicacies, such as that of Sa Pelleteria.

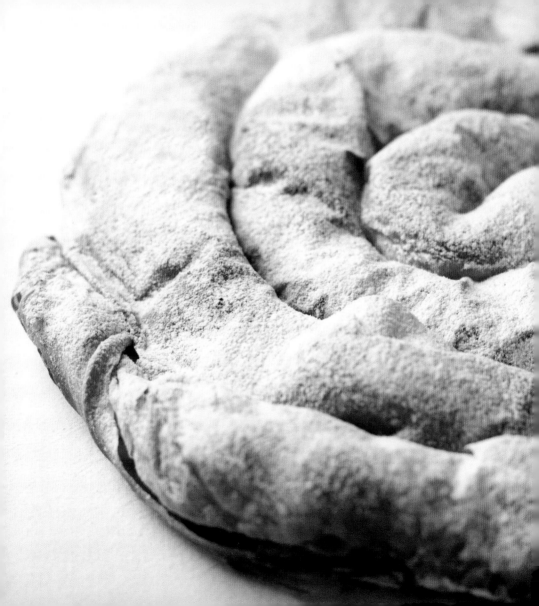

How is an authentic Majorcan *ensaïmada* made?

Although *ensaïmadas* are now produced outside the island, there are those who say the most important ingredients are the island's air and climate. It has even been said that some Majorcan pastry chef's have taken all the ingredients from Majorca to make *ensaïmadas* in other places on the Iberian Peninsula without obtaining the same results. To make an *ensaïmada*, the basic ingredients of which are strong flour, yeast, lard, sugar, eggs and water, plus the desired filling, Majorcan pastry cooks usually follows these steps:

**1** Kneading. The yeast is dissolved in tepid water and all the ingredients are kneaded together by hand, for the time needed to create the smooth, stretchy dough. This dough is then left to rest in a warm place until, with the effect of the yeast, it has doubled in size.

**2** Rolling out. On a floured surface or alternatively greased with oil, the dough is stretched with a rolling pin, also floured or oiled.

**3** Rolling up. The lard is added and the dough once again stretched until it has the appearance of a fine oval crêpe which is folded from the top downwards creating a long thin strip.

**4** Making the strip. Using the hands the dough is rolled to make a strip and left to rest a while to rise from the effect of the yeast.

**5** Stretching. Once the dough has been left to rest, the strip is taken at both ends and carefully stretched and rolled. The turns made at this stage of the process are those which will have the *ensaïmada* ready prepared.

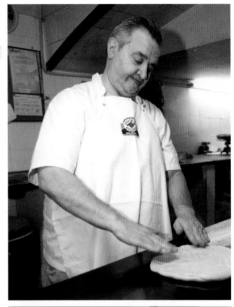

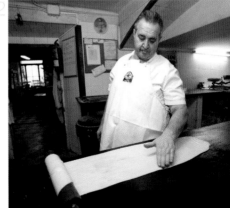

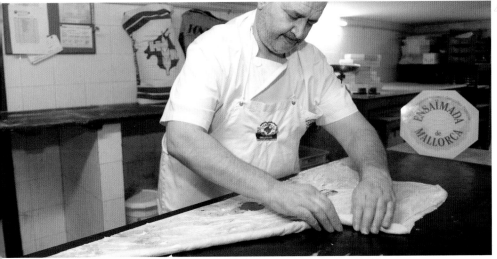

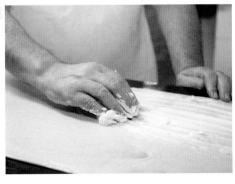

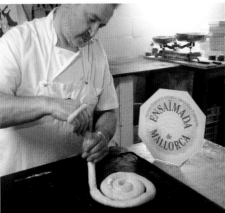

The secret of the *ensaïmada*'s spongy texture is the lard (*saïm*), also from where it takes its name.

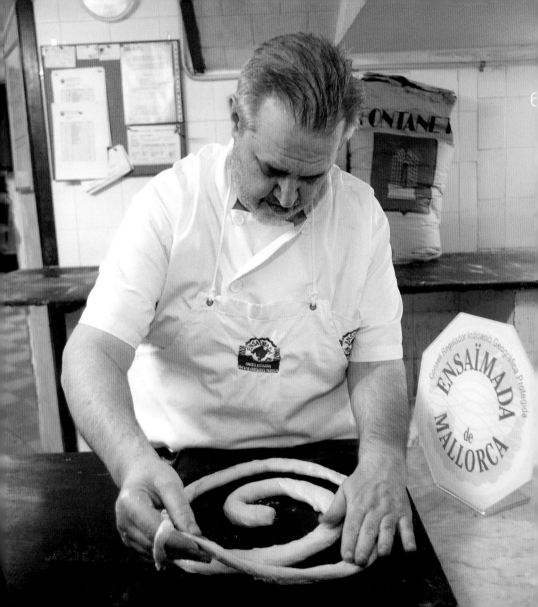

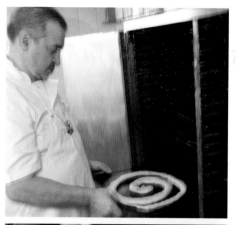

**6 Coil.** Once the strip has been straightened, it has to be coiled like a snake, turning the dough in a clockwise direction with at least two turns literally around its own centre. The strip shouldn't be touching as once it has rested it will rise and the edges will touch.

**7 Fermentation.** The *ensaïmada* is placed on a tray and left to rest for ten to twelve hours. Some pastry chefs use heated cupboards with shelves specifically for this purpose, which they say simulates exactly the right temperature and degree of humidity for the final result.

**8 Baking.** The *ensaïmada* is placed on the tray and into an oven preheated to 180 ° C. The *ensaïmada* is removed from the oven once it acquires a dark golden and somewhat reddish shade and is crusty on the outside.

**9 Dusting.** When the *ensaïmada* is well cooled it is dusted with plenty of icing sugar until completely white. The *Ensaïmada de Mallorca* has now received the Protected Geographical Indication (PGI) which guarantees its quality and prevents imitations. This PGI only refers to *ensaïmadas* without any type of filling (in Catalan, *llises*) and those filled with *cabell d'àngel* (with a minimum of forty grams of cabello de ángel for every hundred grams of dough). The weight of the *ensaïmada* goes from sixty grams up to two kilos and those filled with *cabell d'àngel* from a hundred grams up to three kilos. The small ones are usually eaten at breakfast or in the afternoon whilst the large ones are sold boxed in the traditional octagonal shaped decorative boxes which almost all the island's visitors take with them on their return home.

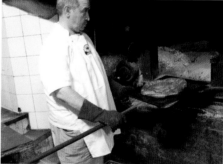

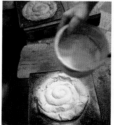

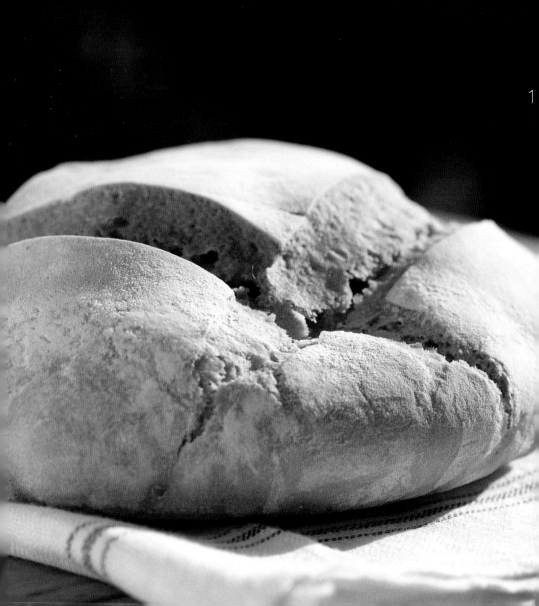

# Baker's delights

bread and cake making in Mallorca are considered to be an art, with numerous bakers producing the sweet or savoury delights typical to this island.

**1** *Pa de pagés.* This traditional round bread is made without salt and can be white or brown according to the flour used. The bread which in the past was eaten by the peasant farmers was made with unrefined flour, the dough mixed once a week and baked in a wood stove to be used in soups, very finely sliced to make what is one of Majorca's most emblematic dishes. As the dish became more refined the bread began to be made with white flour. Nowadays however brown bread is once again seen in a more favourable light and is indispensable for a good *pa amb oli* (bread sliced and topped with olive oil, tomato and salt accompanied by *embutits* and cheeses). Its flavour is stronger than that of the white bread, the breadcrumbs brown and the crust thick and dark which makes it keep better.

**2** *Coca bamba.* This smooth well risen bun is cut into portions and eaten accompanied by chocolate or almond ice cream, the latter being a combination which is second to non.

**3** *Duqueses.* Sweet pastries with thin soft pastry made with ricotta type cheese.

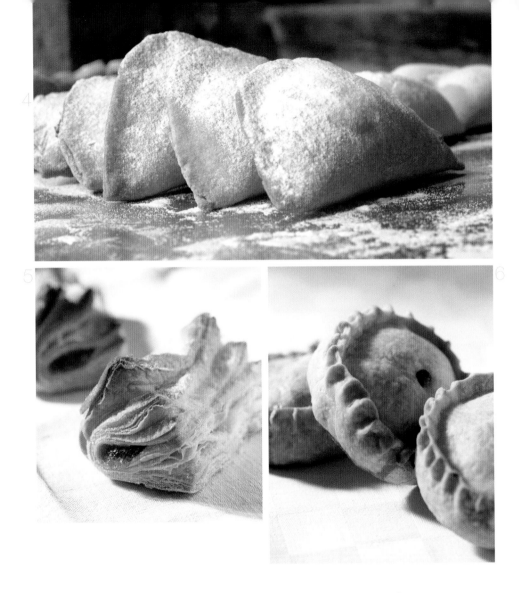

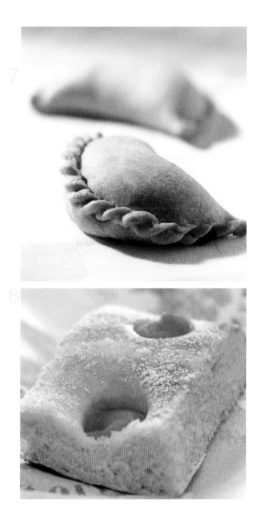

# Baker's delights

**4 Robiols.**
Pasty shaped pastries made from fine flour mixed with olive oil, butter and egg and filled with *cabello de angel* (preserve made with strands of pumpkin in syrup), ricotta type cheese, confectioner's custard or jam. Possibly of Jewish origin as in Sephardic cooking they made similar pasties in the same half moon shape called *borekas*.

**5 Doblegats (folded).** Half moon shaped puff pastry filled with *cabello de ángel*, confectioner's custard or chocolate. The name refers to the fact that the pastry is folded to hold the filling.

**6 Panades.**
Small round pies made without baking powder. The filling can be meat, fish or peas. The most typical are those made with lamb to be eaten at Easter whilst the fish variety was only to be eaten during Lent

**7 Cocarrois.**
Half moon shaped pasties made with very fine flour and vegetable fillings accompanied by raisins or pine nuts, which traditionally were eaten only during Lent. The Jews used to eat some very similar pasties during Passover.

They come in two varieties: vegetable - with chard, spinach, raisins and pine nuts and the second – onion. The pastry can be sweet or savoury.

**8 Coca d'albercocs.**
A sweet sponge cake made in the spring during the apricot season. The apricots are often frozen in order to partake of this delicious cake all year round.

# The expanding wine market

Wine is made up of more than three hundred components which account for its unique structure. According to the experts wine is defined according to its colour, its bouquet and its taste and, as far as taste is concerned, this certainly has to be the most sophisticated product there is. The Balearics are now recovering from the concerns which came with wine making in the 19th century and many wine cellars are now applying the latest technologies to their production and aiming for excellent harvests.

It was probably the Romans who first introduced the vine and developed its cultivation in Majorca and it has remained on the island ever since. One of the most prosperous periods was in the 18th century when an annual wine production of 88,000 hectolitres in 1777 had, by the year 1802, risen to 335,331 hectolitres.

In the 1830's wine making suffered a serious setback due to the poor economy at that time and the onset of aphid plague. However, shortly after that time, France was hit by the phylloxera plague

The island's wines are constantly improving, two wine producing areas now having been awarded a Designation of Origin: Binissalem and Pla i Llevant.

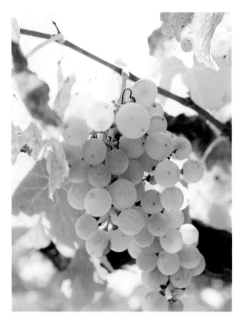

and began to import Spanish and Italian wines to meet the country's considerable domestic demand. Partly as a result of this, vineyards rapidly spread throughout the Balearics. This is illustrated by the mere fact that in 1891 a total of almost fifty million litres of wine left the ports of Palma, Porto Colom and Alcúdia heading for France and the Iberian Peninsula. However, the dreaded phylloxera was soon to appear on the Balearic vines with the result that they were no longer the main source

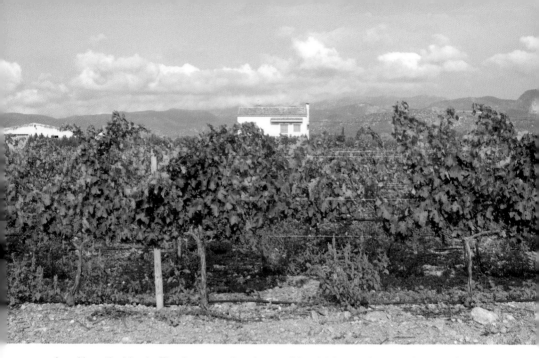

of wealth on the islands. The vines were therefore uprooted and largely replaced by almond trees.

Replanting the vines has, since that time, been a gradual process, initially by means of grafting stems off other varieties on to American roots. During the first half of the 20th century the vineyards gradually began to expand again, but the onset of Civil War caused a setback in vine cultivation with other basic commodities taking priority, such as cereals. As if this weren't enough, at the back end of the eighties a major grapevine uprooting process was initiated, prompted by EU subsidies. However, in terms of quality, the nineties was one of the best wine-producing periods of all times on the islands.

The concerted efforts made by grape growers to improve their produce, together with the heightened consumer interest in natural products from the land, has now put Majorcan wines in their fitting place. There are, in Majorca, two protected wine producing areas, having been awarded the Desig-

The local wines are made by combining grapes indigenous to the island with foreign varieties.

nation of Origin: Binissalem and Pla i Llevant. Wines are also produced in the Tramontana mountains, Andratx and Inca.

**Varieties.** Selecting the grape varieties is one of the most determining factors in the make-up of a good wine, normally by mixing different types of grape which blend together and enrich the final result. Some of the local varieties responsible for giving Majorcan wines their character are the following:

*Manto negro.* A high sugar content grape with a strong bouquet which produces a wine of little colour, with a high alcohol content, low acidity, and sharp. The basis of red wines produced in the Binissalem region.

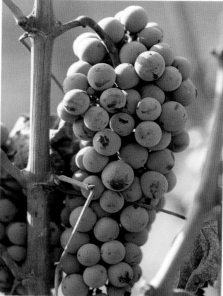

*Callet.* Another black grape found in fruity red wines with little body and low acidity or aromatic, low alcohol rosés. This wine is cultivated in most of the vineyards in the Pla i Llevant region.

*Prensal blanco.* A white variety which gives the wine a pale straw yellow colour, with a strong bouquet of ripe fruit, a fresh clean taste with a fruity, slightly acidic character with body. The principal grape used in both white and sparkling wines produced in the Binissalem area.

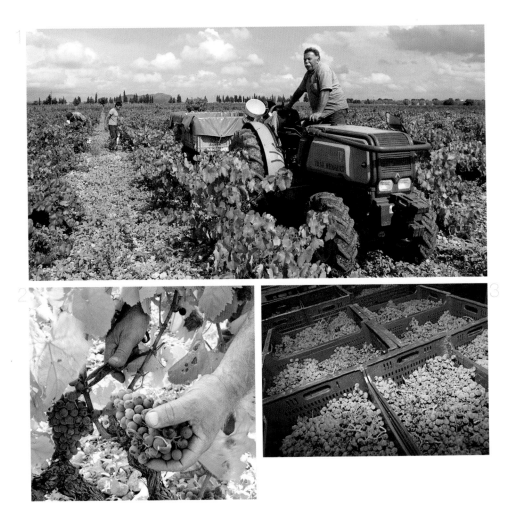

To Produce good wines, in addition to the soil and climate the fermentation process is also of vital importance.

**1** The wine making process begins with the grape harvest, usually from the middle of August to the end of October.

**2** The bunches of grapes are carefully cut.

**3** The grapes are put in baskets or boxes to be transported to the fermentation plants.

**4** Next the grapes are removed from the stem and a mechanical crusher crushes and presses the grapes just enough to prevent the seeds and other solid remains from contaminating the grape juice. From this point on the process followed differs according to whether the wine is to be white, rose or red.

**5** Next comes the fermentation process which usually lasts eight to fifteen days, during which time the sugars in the grape juice are converted to alcohol, various organic compounds and carbon dioxide. Once the fermentation process has finished the wine is repeatedly decanted to eliminate any remaining solids. Finally on to the quality selection process and corresponding mixes to achieve the desired result.

**White wine.** In the case of white wine, before the fermentation process the grape juice is clarified by static decanting at a low temperature.

**Rose wine.** The process for making rose is similar to that of white wine but using black grapes or alternatively a mix of black and white grapes. Before fermentation the grape juice is left to macerate at a cold temperature for a short time with the grape skins, this being the source of the colour. Next the solids are separated from the grape juice which then proceeds on to fermenting.

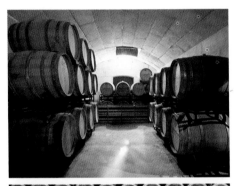

ing a natural barrier which, when it comes into contact with the grape juice, promotes the colour extraction.

**Red wine.** The juice from the black grapes is macerated together with the skins and seeds to give it its characteristic colour. Red wines undergo two fermentation processes: the first or primary fermentation is known as the alcoholic or tumultuous fermentation on account of the activity caused by the yeast. The sugars are transformed into alcohol, carbon dioxide is given off and the colour from the skins dissolves into the juice. The carbon dioxide pushes the skins upwards, creat-

Once the required colour is obtained, the liquid is then decanted - already having been separated from the solids- then on to another tank in which the second, so called slow fermentation is carried out which makes the wine more refined and smooth to taste. The two fermentations over and the wine undergoes numerous siphoning processes as well as clarifying and stabilising treatments. Finally the selection is made according to quality: if taken to be a young wine, it is bottled immediately or alternatively left to complete

the ageing process in wooden casks as required, according to the type of wine. Some red wines are able to undergo a long ageing process during which the complexity of the components increases and the wine's bouquet becomes more intense, refined and satisfying. The final ageing takes place in the bottles themselves, without air. In the past Majorca celebrated the arrival of the new wine by placing a branch from the vine on the door of the bodega. Nowadays some of the old bodegas (*cellers*, in Catalan) have been converted into popular restaurants specialising in local gastronomy.

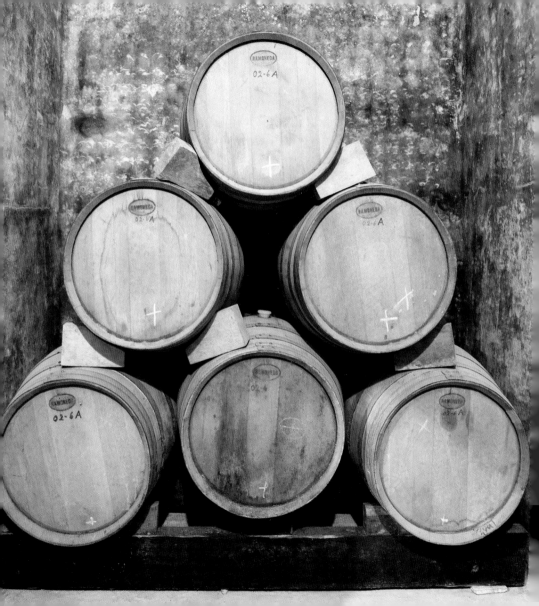

# Designation of Origin

In Majorca there are two wine producing areas which have been awarded the Designation of Origin (DO): Binissalem and Pla y Llevant. In Binissalem the DO protects red, rose, white and sparkling wines made principally with grapes from the indigenous Manto Negro and Moll varieties. The high alcohol content red wines are full bodied with a strong, well balanced, personality and are suitable for ageing. The whites are different, delicate and fruity.

The wine-producing area of the Binissalem DO is located literally in the centre of Majorca and encompasses the towns of Santa Maria del Camí, Binissalem, Sencelles, Consell and Santa Eugènia. The area is protected from the cold north winds by the Tramuntana Mountains with the resulting mild microclimate with hot dry summers and short winters.

The Pla i Llevant DO is one of the most traditional wine producing districts, having cultivated vines here since the time of Roman occupation. Involved in the wine production are the towns of Algaida, Ariany, Artà, Campos, Capdepera, Felanitx, Llucmajor, Manacor, Maria de la Salut, Montuïri, Muro, Petra, Porreres, Sant Joan, Sant Llorenç des Cardassar, Santa Margalida, Sineu and Vilafranca de Bonany.

# Wine festival

Every year, during the last week of September, the *Fira des Veremar* (wine harvest festival) is held in Binissalem which also includes the Designation of Origin Binissalem-Mallorca festival, an event in which almost all the local bodegas participate. The event is a real grape and wine festival with float processions, outdoor celebrations, folk dances, displays relating to the grape harvest, grape crushing contests, etc. One example of the area having retrieved and restored its wine-producing activities is that in 2005 almost six hundred hectares were set aside for the production of wine which came under the Designation of Origin and which, together with fifteen bodegas, produced more than eighteen thousand hectolitres of wine.

The wines regulated by the Binissalem Designation of Origin are reds, rosés, whites and sparkling. The most commonly produced and most well-known are the reds, particularly "*crianza*" or vintage wines. In the white wines, it is predominantly the Moll grape which gives the wine its characteristics, these being wines with a very fresh fruity bouquet.

All the local inhabitants in and around Binissalem take part in the festival. A total immersion in wine culture.

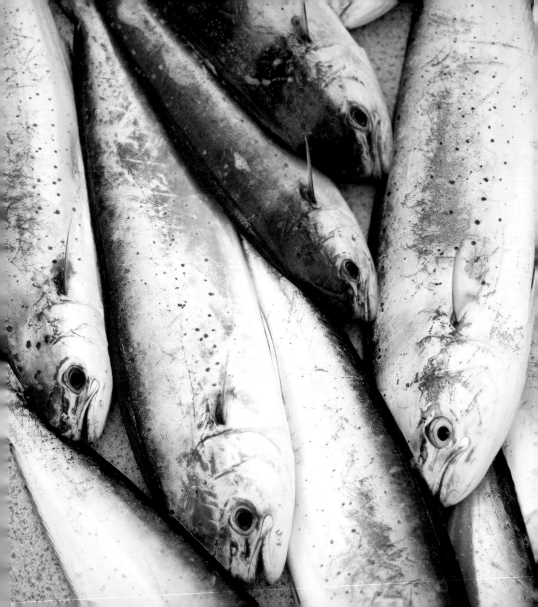

# Seafood gastronomy

"Once fish enters the kitchen it suffers a transformation which we could say is detrimental to its appearance but which favours its domestication. The woman who almost suffers a heart attack on seeing a writhing lobster just pulled out of the water gazes affectionately over the same crustacean served at the table; .. Man worships change, the only source in his organism which doesn't segregate sadness is the imagination". The words of Josep Pla – Catalan traveller, gastronome and writer who has travelled to and around Majorca on numerous occasions – illustrate the passion and gastronomic appeal which exudes from cooking fish and seafood.

Being an island, Majorca has benefited not only from the sea's produce but also from the imagination combined with necessity with the resulting excellent recipes. The majority are dishes created by the fishermen themselves which they can now enjoy in the island's best fresh fish restaurants, some of which even have their own boat. To assess the Balearic Sea's riches one needs only to stroll by the fish markets and stalls or watch the fishermen unloading the daily catch in any one of the island's busiest ports, Palma, Santanyí, Port d'Andratx, Sóller, Alcúdia or Cala Rajada.

One of the most commonly consumed fish is the grouper, a high quality white fish with a mild delicate flavour. Although this fish can be prepared in a variety of ways more often than not it is oven baked and accompanied by vegetables.

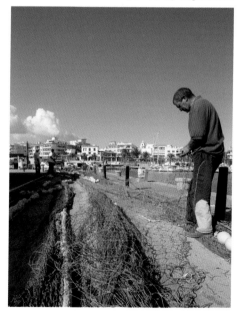

The common dolphinfish is frequently consumed in Majorca although only fished at the end of summer from traditional fishing boats.

The entire fish can be put to good use: the head can be used to make an excellent fish stock or add flavour to soups and rice dishes. Another well loved species is the sardine which, in the summer is grilled in the open air with a dash of oil and sea salt, although it's equally as delicious dipped in flour and fried. The secret, as with all fish, is that the sardines are fresh.

The red mullet is also well appreciated throughout the Mediterranean, the great chefs having established it well in the world of haute cuisine. On account of its delicate flavour, this fish is best not overcooked and it makes an excellent combination with sautéed vegetables and aromatic herbs and, once fried, oozes a delicious oil, not to be disregarded. The Romans were great lovers of red mullet, it being one of the ingredients in *garum*, a very popular sauce served with all types of dishes. It was prepared by placing layers of fermenting fish on top of a bed of aromatic herbs and covered with a layer of salt.

The *picarel* (in Catalan *gerret*) is a particularly well loved species in Majorca with a soft texture and an intense aroma. Its price is affordable and usually found in the markets above all in the win-

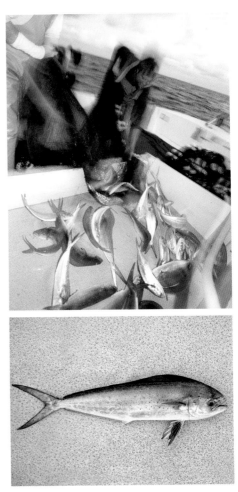

To catch the dolphinfish or *llampuga* special nets are used called *llampugueres*, which surround the floating objects beneath which the fish are known to gather.

ter months. The females are more highly valued than the males, on account of having more oil. Traditionally the *gerret* is fried in olive oil or pickled although it can also be used to flavour fish stews.

The skate or ray, a white fleshed cartilaginous fish, is also very popular. Various types of rays are sold in the markets, most commonly the thornback ray which is also the best quality, and secondly the brown ray. The edible parts are the fins and the central part of the skeleton. Having a strong flavour it is best marinated for a few hours before cooking. Can be eaten either fried in olive oil, pickled, with vermicelli or stewed with potatoes and vegetables.

The *círvia* (greater amber jack) is one of the largest Mediterranean species and can weigh up to fifty kilos. The young specimens are known as *verderoles* and eaten fried or pickled. The flesh is compact and firm with an exquisite taste, the

A valuable cultural and economic heritage for Majorca is the traditional fishing which makes selective catches.

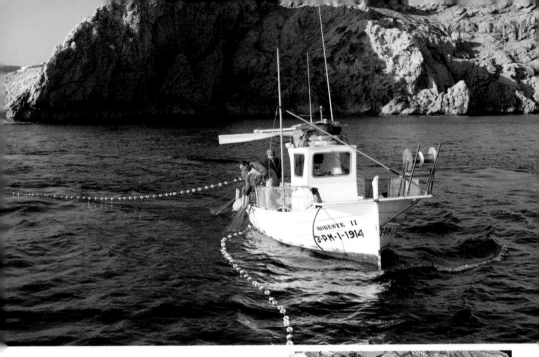

larger pieces sliced and eaten grilled, pickled or stewed.

The red scorpion fish (*cap roig* in Catalan) is well appreciated for its consistent firm white flesh which gives off an intense aroma of the sea. An indispensable ingredient in bouillabaisse, a fish and crustacean stew which is strained and the fish served separate. In Majorca the red scorpion fish is usually prepared and eaten in the simplest way, grilled or boiled and accompanied by potatoes and vegetables.

The island's most active fishing ports are those of Palma, Santanyí, Port d'Andratx, Sóller, Alcudia and Cala Rajada.

Octopus is a cephalopod which is fairly well consumed on the island, whether it be stewed with onion, cooked and sprinkled with olive oil, paprika and course salt or as the main ingredient for the stupendous frit de pop, stewed with potatoes and vegetables and seasoned with fennel and other spices. It has a solid flesh which needs either to be cooked for a fairly long time or some other tenderising method needs to be employed (freezing before use or pounding). Not to be forgotten is either the squid, eaten grilled or filled with various combinations or the cuttlefish which makes an excellent stew combined with onion, raisins and pine nuts or with onion, tomato and a touch of *sobrassada*.

Amongst the seafood and shellfish both the red lobster and pink prawns are a must, best of all grilled without any embellishment whatsoever. The lobster is also the main ingredient in some memorable dishes such as the Majorcan seafood stew or *caldera* or the *llagosta marinera*, the latter with rice.

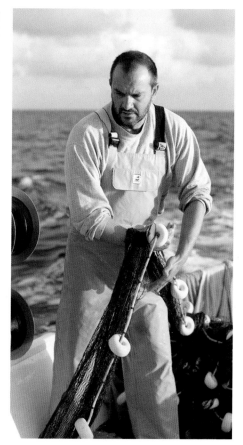

Some of the best fish and seafood restaurants are supplied daily by catches from their own boats.

# Fish
# and heritage

Majorca's most patrimonial fish is without doubt the *llampuga* or common dolphinfish. Some say its name comes from the Catalan verb *llampegar* (to flash) and the fact that the start of the fishing season also coincides with the appearance of storms at the end of the summer. Others believe the name to be of Latin origin as in *lampere* (to shine), referring to this fish's shiny golden colour (the fish is in fact also known by the name of *dorado* in Spanish meaning golden). Although not considered to be one of the prime fish varieties its flesh is succulent with an intense flavour.

Fished at the back end of summer when the young specimens appear in abundance in the Mediterranean, the fish is caught with *llampugueres*, special nets which go around floating objects beneath which the dolphinfish are usually to be found. The fishermen, taking advantage of this habit, attract the fish by lowering buoys (*capcers*) and afterwards dropping the nets. The fishing itself is carried out on board traditional fishing boats or *llaüts* and most of all from the ports of Sóller, Pollença, Andratx, Porto Colom, Cala Figuera and Cala Ratjada. In some medieval Majorcan recipe books references are made with regards to cooking methods for the dolphinfish. Nowadays it is consumed preferably grilled, pickled or fried in olive oil and accompanied by fried red peppers or *tombet* (a delicious dish based on potato, aubergine and red pepper).

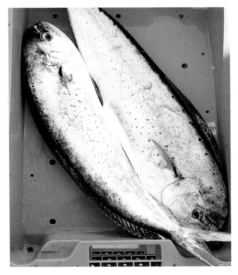

Huge numbers of dolphinfish appear in the Mediterranean at the end of summer and are fished from *llaüts*.

# Mostra de la Llampuga

The *Mostra de la Llampuga* is an annual gastronomic food fair held in Cala Ratjada, Capdepera, in the third week of September. Coinciding with the fishing season for this species, more than three thousand kilos of common dolphinfish are cooked in both traditional and innovative recipes. Numerous establishments participate in the event with a various offerings and those in attendance can sample various dishes for the price of a set meal. The event itself is very much a festival with live music performances and exhibitions of fishing tackle from bygone times and photographs.

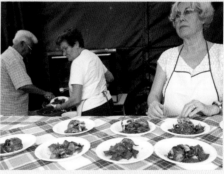

Creative dishes can be sampled such as dolphinfish quiche, dried dolphinfish pasta, dolphinfish and prawn croquettes, pickled dolphinfish, or alternatively the traditional dolphinfish with fried red peppers, which everyone has to taste at least once in their lives.

The *Mostra* takes a gastronomic tour through the many different dishes created around the dolphinfish, both traditional and innovative.

# Liquid gold

Olive oil transforms any food into gold. To food it adds personality, improves the quality, transforms the texture and imparts aroma, flavour and colour. In Mediterranean cooking olive oil is a basic essential and for thousands of years besides being a food element it was also used as a balsam, ointment and ritual oil. Modern dietetics has literally fallen to its feet in awe of olive oil, finally treated with the respect it deserves both in respect to its culinary as well as curative virtues, known as it is to reduce certain types of cholesterol and reduce the risk of coronary heart diseases.

The Spanish word for oil "*aceite*" comes from the Arabic *al-zait* meaning olive juice. It was the Phoenicians and Greeks who first introduced the olive to the Iberian Peninsula and the Romans and Arabs later improved its cultivation and production. The olive oil trade helped to develop the Mediterranean economy at the same time becoming the basic fat used in the region's cooking. Almost ninety percent of current olive oil production continues to be made in the Mediterranean.

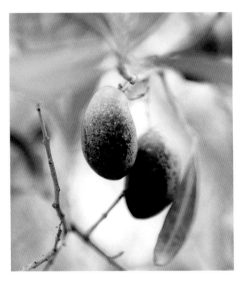

In Majorca extra virgin olive oil is produced under the protected Designation of Origin, made on the island with Majorcan olives of the *arbequina* or *picual* varieties. The degree of the olive's ripeness at the time of picking denotes the nature of the oil: fruity or sweet. The first comes from the earlier picking whilst the second is made with riper olives and is characterised by its golden yellow colour and mild flavour.

The island's climate and geology favours the production of an olive oil which is sweet and fruity and full of character.

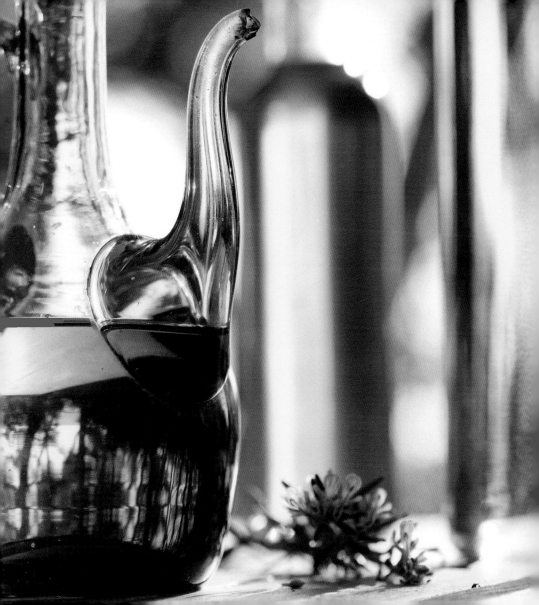

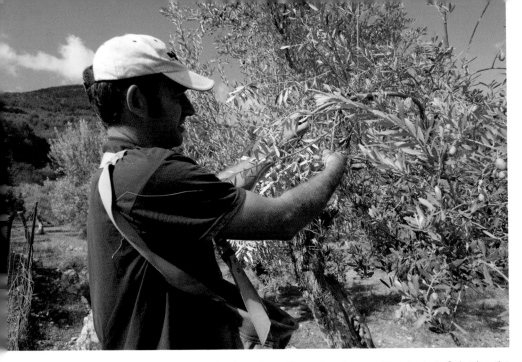

The type of soil, the climate, the irregular rainfall and the excessive age of Majorcan olive trees – some five hundred years old – makes it dependant only on a scant production of suitable olives to make quality oil. These factors and the type of olives found in Majorca give rise to olive oils with highly distinctive characteristics.

The oil produced on the island has been praised since times of old. In Die Balearen, one of the finest and most documented works on local life and customs written by Luis Salvador, the Archduke of Austria, during his stay in Majorca at the end of the 19th century, the quality of the olive oil is praised for its use in salads and the simple but delicious *pa amb oli* (bread and olive oil), one of the most recurrent and popular dishes in the island's homes.

In the 13th century under the Crown of Aragon, the island was already exporting oil and other produce to North Africa. In the 16th century oil

The fruity olives are the green variety whilst the sweet olives are the mature variety with more nutrients.

production was the main source of income for many country estates, some of which had their own olive oil mill. Olive tree cultivation expanded above all over the northern and southern regions of the Tramuntana mountains.

Until the 19th century olive oil was a basic ingredient in the Majorcan people's diet and essential to the island's economy, eventually coming to represent between 65 and 80% of the island's exports, the proceeds of which went to pay for imported products such as wheat, of which the island was in scarce supply.

## Production. The production and manufacture of olive oil extends throughout nearly all the municipalities in Majorca. Certain environmental factors are conducive to the olive tree's cultivation such as the high humidity levels. This means that in spite of the scarce rainfall, the olive trees adapt easily to the dry periods, stabilising the olive production, their chemical composition and, consequently, the quality of the olive. Another positive factor is the presence of the Tramuntana mountains to the north of the island, an enormous natural barrier protecting the olive groves from the destructive north winds.

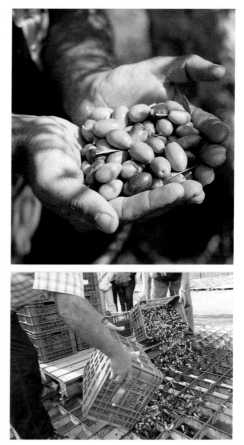

The olives are selected before pressing to make the olive oil.

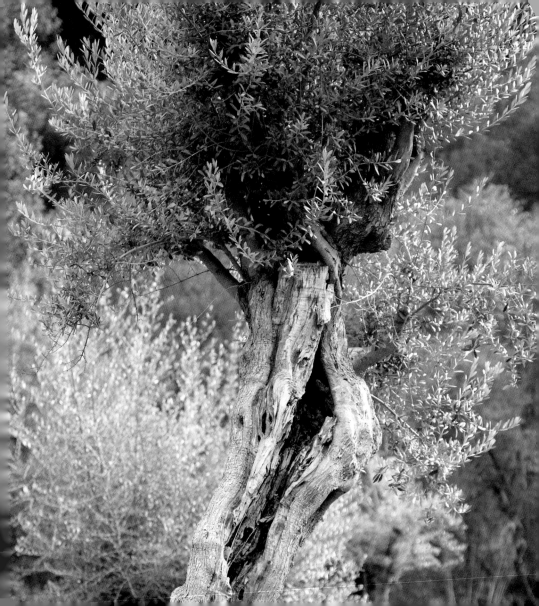

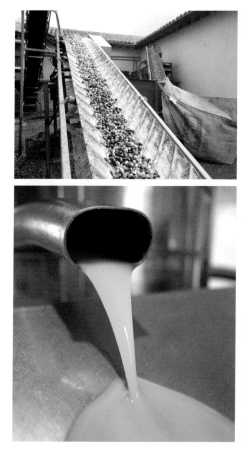

The olive groves are set on plots of land located at various altitudes, from sea level up to eight hundred metres in the more mountainous regions. To protect the slopes, for centuries the mountain groves have been cultivated in terraces which, aside from preventing land erosion, also makes for one of the island's most emblematic landscapes. The south facing mountain terraces make the most of the midday sun and also escape the cold north wind. Nevertheless, at times it is still difficult to access these groves, something which has an influence on the cultivation methods used. Generally, the mountain groves are less productive than those on the flat lands, mechanisation and picking being more difficult in the steeper areas. All this results in the olives being picked at an advanced stage of ripening which, in turn, gives rise to an olive oil with a characteristically sweet and very mild flavour.

In Majorca the oil is still produced by traditional methods. The olives are crushed between stone wheels called *rutlons*, producing a paste which is then placed between stacked esparto mats to be pressed. The resulting liquid is a mixture of oil and water which is then left to rest to be able to

Some olive-oil mills use a continual process to make the olive oil, in which the extraction process is automatic.

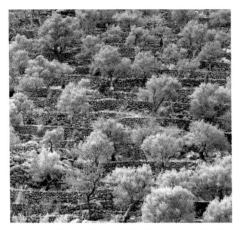

be replaced, the reason for which the Tramuntana mountain groves date back five hundred years. Olive groves are part of the Majorcan landscape and the Majorcan people declare their olives, the subject of stories and legends, to be ancient. There are also much newer groves which are, at the most, ten years old.

The age of the olive trees is a contributory factor as regards the distinguishing characteristics of the olive oil produced in Majorca. The oldest trees have nutritional elements in reserve which are activated when the fruits are formed, their olives being more aromatic than those of the young trees. This same aroma is preserved in the oil. On the farms quite often olive tree cultivation is combined with sheep rearing, these animals well adapted to the climate and serving a duel purpose: to eliminate the weeds and supply organic fertilizer. This combination of trees and animals also helps to minimize the use of pesticides and fertilizers, avoiding any contamination of the environment and making the farm more profitable.

separate them. Many industrial olive oil mills manufacture olive oil by continuous system, in which the entire process is automatic. The olive oil is then classified, according to quality, to be stored in tanks at the appropriate temperature and later bottled and protected from the sunlight.

## Ancient olive trees. The earliest indications of the existence of olive trees on the island of Majorca date back to the 15$^{th}$ century, although it wasn't truly cultivated until a century later. The trees have survived without experiencing either the plagues or fires which usually force them to

The Tramontana mountain terraces save the slopes and also make the most of the rainfall.

# Green, black and cracked

Olives are never absent when it comes to Majorcan appetisers, a tradition inherited from the Romans: taken before the meal they stimulate the gastric juices and facilitate digestion. On the island they are often accompanied by *pa amb oli* or bread with *sobrassada*. Many families prepare their own olives following recipes which have been passed down through the generations. Green olives are picked in the early autumn, whilst the black ones are picked from December onwards, by which time they are already very ripe. The latter are the more nutritious variety, having remained on the tree longer they contain less water but more nutrients and oil.

In Majorca there are three different types of olives: whole green olives, cracked green olives and black. The most traditional are perhaps the cracked olives, with an intense and slightly bitter flavour. To prepare the olives, only the best are selected, rejecting any which are overripe or damaged. They are then crushed with a wooden mallet, without breaking the stone and left to soak for a week to eliminate any bitterness, the water being changed daily and using a glass container, layers of olives are alternated with pieces of lemon, sprigs of fennel and bay leaves. Finally all is covered in brine (using water which has been previously boiled and left to cool, adding between twenty to thirty grams of salt per litre). After three to four weeks the olives are ready to eat.

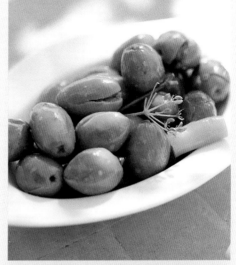

# Landscape and gastronomy

The almond is part of both Majorca's landscape and its gastronomy. The almond groves scattered throughout the island are a particularly beautiful sight in winter when they attracts thousands of visitors. The importance of this crop is also reflected in the island's gastronomy the almond being an indispensable ingredient in traditional dishes, both sweet and savoury.

It was in back in the 18th century when vast almond groves were planted, the produce from which remained profitable for almost two hundred years. They did in fact come to replace the Majorcan vines at a time when these were attacked by the philoxera plague. Almond groves began at that time to cover great expanses of land, often combined with other crops such as cereals.

Between 1940 and 1950, however, the almond tree entered into a decline. Newly planted trees, often sown on inadequate lands, proved to be unprofitable and the post war climate favoured the cultivation of cereals which were in greater demand at the time and better paid in times of hardship.

Curiously it was the tourist industry which finally gave an unexpected boost to the almond tree: Majorca's almond groves in blossom having served as a tourist attraction ever since that time. The fact is that the winter landscape with these trees in flower at the foot of what are, at times, snow covered mountains, is one of the most poetic metaphors there are to represent the onset of spring.

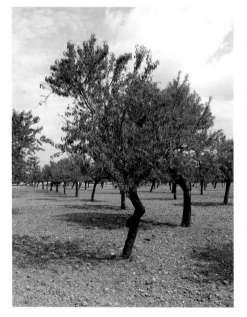

Almond tree cultivation covers more of the island's land than anything, with many almond groves usually extending five or six hectares.

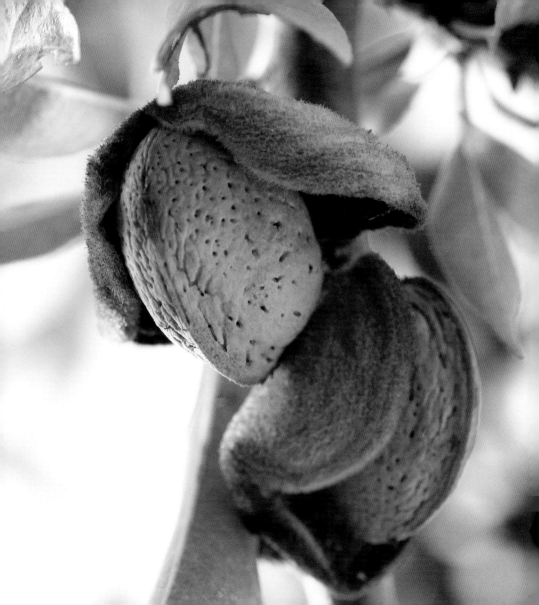

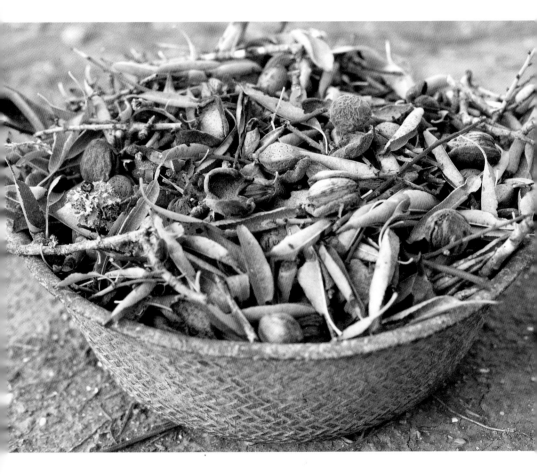

In some houses almonds are toasted and served as an
accompaniment to an aperitif.

The Majorcan almond has now made a full recovery. This is the most extensive of the island crops although there are few farms which live exclusively off its production, usually being combined with carob trees, crops which are suitable for non-irrigated lands and flocks of sheep, often seen grazing amongst the trees.

The majority of farms are small, between five or six hectares, with an average production of three hundred kilos per hectare.

The main almond production areas are concentrated around the towns of Marratxí, Bunyola, Santa Maria, Sencelles, Lloseta, Selva, Manacor, Sant Llorenç and Son Servera. In recent years the Majorcan almond has fallen foul of the competition from Californian prices although some experts maintain that the island's indigenous variety has more flavour on account of its higher fat and sugar content.

To promote the production and consumption of almonds, the Association for the Promotion of Majorcan Almonds created the collective quality mark "*Ametla Mallorquina*" (Majorcan Almonds). This identifies the almond to be of the (*Prunus amygdalus B.*) variety which is singled out for its flavour and oiliness, particularly suitable for con-

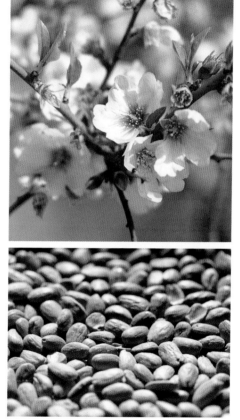

The winter landscape with hundreds of almond trees in blossom has served as a tourist attraction and continues to attract thousands of visitors.

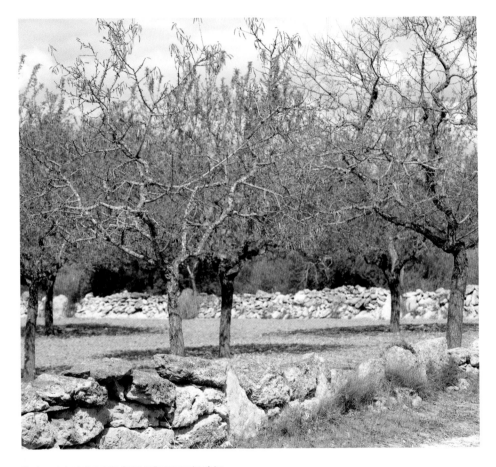

The boundaries between the farms or *fincas* consist of dry stone walls, an art which is clearly undergoing a revival throughout the island.

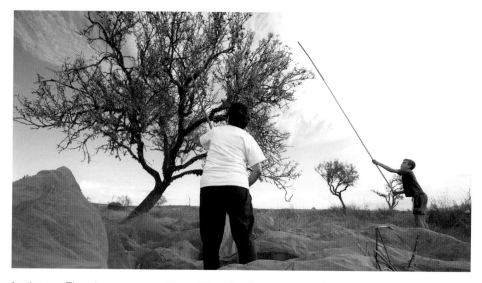

fectionery. The almonds are sold in different forms (with or without shell, whole, etc.) to meet the needs of the consumer.

In many houses and farms with an almond tree or two, the almonds are toasted in the oven and eaten and offered as an appetiser. In savoury dishes they are often combined with garlic and other ingredients to add consistency and flavour to stews and they are also incorporated in the stuffing which accompanies the Christmas suck-ling pig (*porcella*), prepared in the Llevant area. In sweets the almonds are used to make the nougat-like *turrons* such as *cocas de turró*, *turró de Xixona* or marzipan and the *tambor de ametlla* – ice-creams (which can be prepared equally with raw or toasted almonds), traditional mini pastries (bitter with a crumbly texture), more substantial desserts such as *gató* or nutritious almond milk, a refreshing drink of medieval origin made with pressed almonds and water.

Collecting the almonds is done manually or with the aid of machinery depending on the size of the farm.

# A heavenly gift

Honey was one of the first delicacies known to mankind, praised by Virgil in his introduction to The Georgics: "Now I will sing the praises of honey, this rose of the air, this sweet gift from the heavens". The Greeks and Romans used it as a cooking liquid, combining it with other ingredients to make stuffing for meat, terrines, puddings and sauces. The Arabs engulfed their desserts with honey and it has also served to conserve fruit both whole or in jams and marmalades. In the Hindu kitchen it was used to preserve meat for months. From ancient times up until the Renaissance it was used as a sweetener and condiment to many dishes, mixed with spicy or fragrant substances.

Honey is a natural product made by bees to feed their larvae and its flavour, colour and aroma differs depending on the species of flower from which the insects have drunk the nectar. The worker bees transform the nectar (a sweet substance secreted by the flowers to attract insects) into honey in their stomachs.

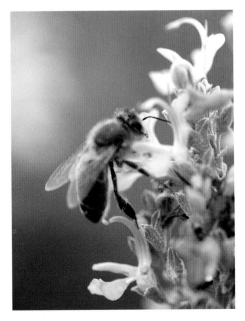

Honey has been produced in Majorca for literally centuries. Beekeeping, the breeding of bees for crop pollination, collecting honey and other products, is an ancient art, which apparently originated in the Near East. The Egyptians were already breeding bees thousands of years ago and trading them along with the wax and honey on the East African coast. Until the 19th century beekeepers collected the honey and wax by killing or making the bees drowsy, that is until dis-

In Majorca the famous mille-fleurs honey is made from carob or almond trees blossom, amongst others.

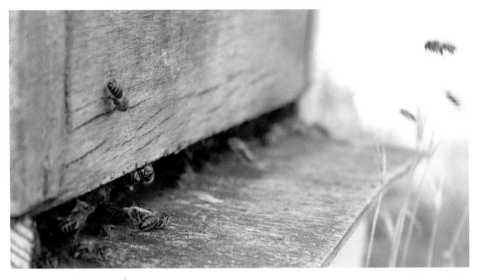

coveries made by Lorenzo Lorraine Langstroth, from North America, made it possible to collect these products without destroying the bee colony.

Honey is actually nearly eighty percent sugars which the human organism rapidly absorbs. No other natural product provides so much energy as quickly as honey. Aside from the water content in honey there have been found to be more than 180 components: almost all minerals and various organic and amino acids. Some of its properties are lost on heating and it is best kept in a cool dry place without light.

In the Balearics there are around eleven thousand beehives, each with an average yield of 6.36 kilos which between them produce seventy thousand kilos of honey per year. The most commonly produced variety is the well-known "mille fleurs". For Majorca's honey production two collections are made: the first is a poly-floral

There are eleven thousand bee colonies on the island which annually produce around seventy thousand kilos of honey.

variety known as May or spring honey with a pale amber colour and rich in vitamins and minerals. The second is November or All Saints, basically collected from the carob tree and which is very dark and has a tendency to solidify, not quite as sweet and aromatic as the first. Some beekeepers collect the honey immediately after a certain blossoming in order to obtain such as almond blossom honey, an intense flavour with a slight bitterness.

On the island, honey is used above all as an ingredient in sweets and desserts such as *turrones*, marzipan, cakes and pastries and also to make mead and liquors, as well as in some savoury recipes. One of the most surprising delights is that of *sobrassada* with honey: the *sobrassada* is fried and spread over slices of toasted bread and sprinkled with a dash of honey. Chard dumplings are also made with honey. As for desserts, *llesques de Papa* or French toasts are excellent sprinkled with honey prior to eating. There are also some mead producers, a drink which has been made since the Middle Ages from alcoholic fermentation, diluting the honey with water and adding some extracts, spices and fruit juices.

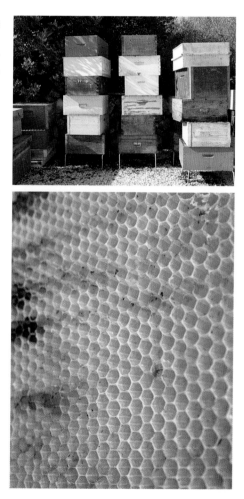

Some beekeepers collect the honey after a specific blossoming, such as that of the almond tree.

# Liquors:
## *hierbas* and *palo*

Majorca's liquors par excellence are *hierbas* and *palo*. Both have medicinal origins, such as being a remedy for fever, worms or stomach ache. These traditionally made and consumed drinks are now protected by a Geographical Indication which guarantees their quality.

**A fusion of herbs.** *Hierbas* is made by marinating aromatic plants in alcohol. Sixty days is all it takes to give rise to a complex drink with a very distinctive mixture of aromas. Since time immemorial the Majorcan people were well aware of the medicinal properties of various wild herbs such as peppermint, fennel, mint, rosemary or camomile, which for centuries were used in herbal teas to combat certain illnesses. Given that some of these infusions had a rather bitter taste, sugar began to be added, a habit which was maintained when it came to making the so called "*hierbas dulces*" or sweet *hierbas*.

The origins of home-made *hierbas* goes back as many as two hundred years. Many families still maintain the tradition of placing sprigs of aromatic

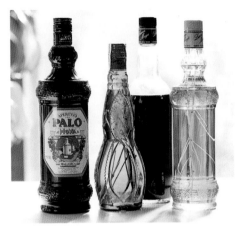

herbs in a bottle to marinate in anis, the herbs are collected in May and June and the mixture is a highly guarded secret passed down through the generations. To partake of and offer a home made *hierbas* is a ritual which gives equal pleasure to the host and the guest.

*Hierbas* started to be mass produced in the 19th century and in spite of the fact that statutory regulations specified how it was to be made each factory still had its own little secrets. *Hierbas* contains, amongst other herbs, lemon verbena, camomile, orange, lemongrass, rosemary, lemon balm and fennel, all collected in Majorca.

To extract their aromas a distillation and/or maceration process is used. The resultant liquid is

Amongst other herbs *hierbas* liquor contains lemon verbena camomile, rosemary, lemon balm and fennel.

known as *palo quina*, which comes from America, and which was used to make infusions to reduce fever. Sugar combined with other substances gives it an agreeable taste and its alcohol content puts it amongst the aperitifs.

Towards the end of the 16th and beginning of the 17th century seafarers brought different varieties to the island to exchange for oil. Mosquitos were rife in the humid zones and fevers therefore common. The cinchona bark and gentian root extracts proved to be very useful in combating fevers and to make them more palatable they were combined with grape syrup, dry figs or ground carob.

Palo finally came into being in the 19th century, as a result of the hydro-alcoholic maceration of cinchona bark and gentian root and the addition of caramelised sugar. This intensely dark and dense aperitif is usually taken with ice and soda or alternatively with ice, a little lemon juice and a shot of gin. The production process has changed slightly and now before bottling it has to be stored in oak casks.

transparent and the colour green to amber. *Hierbas* comes in three varieties: sweet, blended or dry.

**Caramel aperitif.** The Andes is known for famous aperitifs which awaken the appetite, stimulate the gastric juices and promote digestion. Palo is one such aperitif, a traditional drink, thick and dark which at a single swallow, prior to eating, affirms the taste of toasted almonds. The basic ingredients are cinchona bark and gentian root and its name is derived from the cinchona bark, also

Palo is either taken with ice and soda or ice, lemon juice, and a few drops of gin.

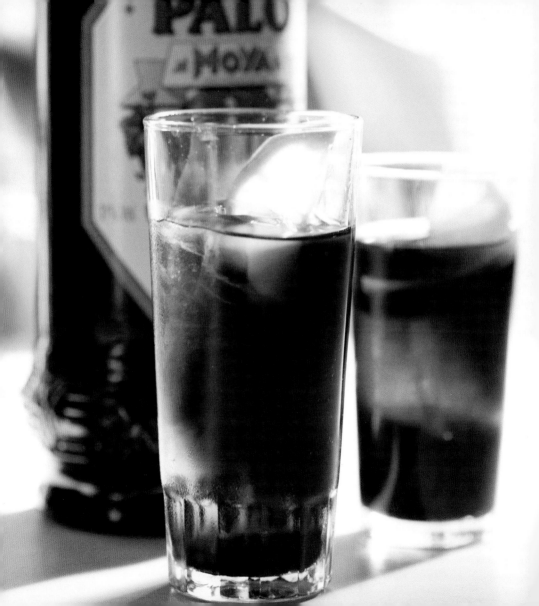

# Conserves
## and other products

For centuries conserves have been made in Majorca using age old techniques: preserves and jams (conserves based on adding sugar); pickled olives, capers and caper buds (*tàperes y taperots*); and dried apricots, figs, peppers and tomatoes, conservation based on drying and losing their water content.

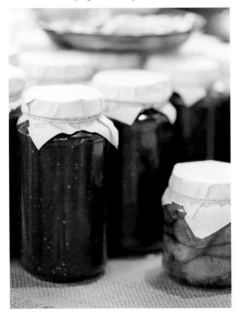

These techniques have enabled the inhabitants to have food available during the cold winter months or the prolonged dry spells as well as making good use of any surplus stocks.

Jams and preserves are made by cooking fruits whole, chopped or crushed with the addition of sugar. In the rural world, every household made its own preserves with any surplus uneaten or unsold fruit.

Capers and caper flower buds are also a basic conserve and an accompaniment to many dishes. The caper buds are the future flowers of the caper bush, of Asiatic origin which grows spontaneously amongst the rocks and between the walls close to the sea, although at times it is also cultivated. The fruits are elongatet berries known as capers. Both the capers and caper buds are conserved in vinegar which inhibits the grown of micro-organisms.

On the island it is customary to dry apricots, figs, tomatoes and red peppers (the latter to make paprika). The apricot, fruit of the apricot tree, is dried without the stone and halved to be used in *ensaïmadas* and cakes.

Conserves make it possible to have certain foods available when they are out of season or in short supply, or during the cold winter months.

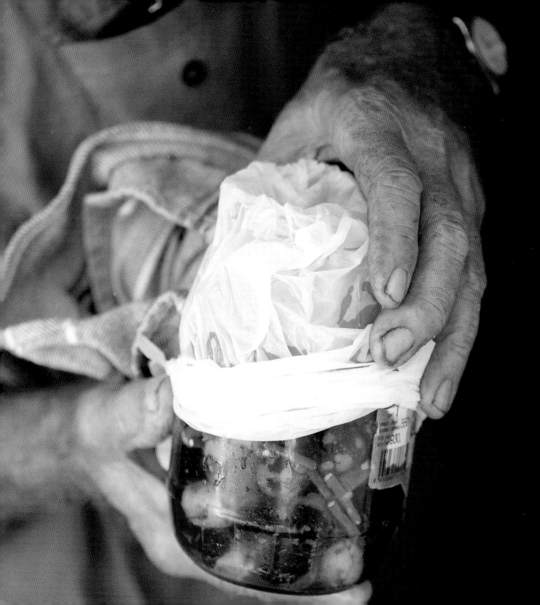

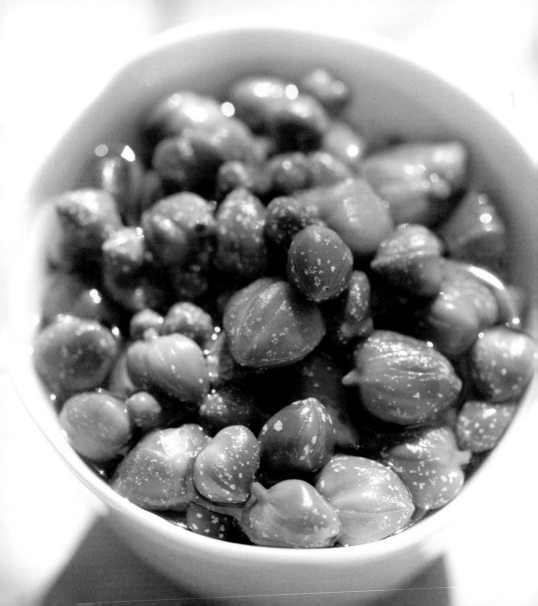

**1 Caper flower buds.** Pickled caper flower buds are used in many dishes: from pizzas and pastas to all types of meat and fish dishes. They are also eaten as an appetizer and are the basis of sauces such as tartar sauce, a highly suitable accompaniment to smoked salmon or steak tartar. Also an essential ingredient in Majorcan dishes such as tongue with capers (*llengua amb tàperes*), and the perfect accompaniment to *pa amb oli* and *trempó* (a summer salad based on onion, tomato and green peppers).

**2 Dried tomatoes.** As in other places in the Mediterranean tomatoes are also dried in Majorca. Their flavour is distinctive, for some maybe even too strong. They can be conserved in olive oil and eaten accompanied by a good fresh cheese or chopped to add flavour to salads and stews.

**3 Jams and preserves.** Traditionally in the Balearics preserves were made from plums and apricots but, to forestall the competition, local companies have opted to provide home made preserves with more adventurous Mediterranean flavours, in some cases with products of limited com-mercial value: figs, prickly pear, pomegranate, bitter-pomegranate (*magrana agre*, excellent with meats such as pork), quince, watermelon, melon, grapes, etc. These preserves are made using modern techniques under the strictest quality controls and only with fruit, sugar and citric acid. The preserves are generally sweeter than the jams and the quantity of fruit depends on the category of the product.

**4** **Capers.** The caper is the fruit of the caper bush, also preserved in vinegar or pickled and eaten as an appetiser or as an accompaniment to *pa amb oli*. Picking capers and the caper's flower buds is a traditional activity which has gradually lost its way over the years due to the labour involved. In Majorca they are cultivated in the Campos and Llubí districts with some large cultivations in Sineu.

**5** **Dried figs.** Dried figs are also typical of Majorca, used to make varies cakes and desserts. In rural societies, figs were a part of everyone's diet, regardless of social class and drying them was a commonplace activity which required delicate treatment and enabled this fruit to be enjoyed al year round. They were also an important source of energy for carrying out agricultural tasks. Dried figs were used to create recipes as diverse as fig cake (*pastís de figa*), *escaldulms*, young pigeon with honey and dried figs, *pa de higo* (dried fig and almonds crushed together in the shape of a round cake) or figs marinated with anis and liquor.

**6** *Fonoll mari* (pickled sea fennel) is an island speciality. This conserve always comes as a pleasant surprise to visitors, being a real delicacy which can only be found here. Served either as a side dish at informal meals or with the omnipresent *pa amb oli*.

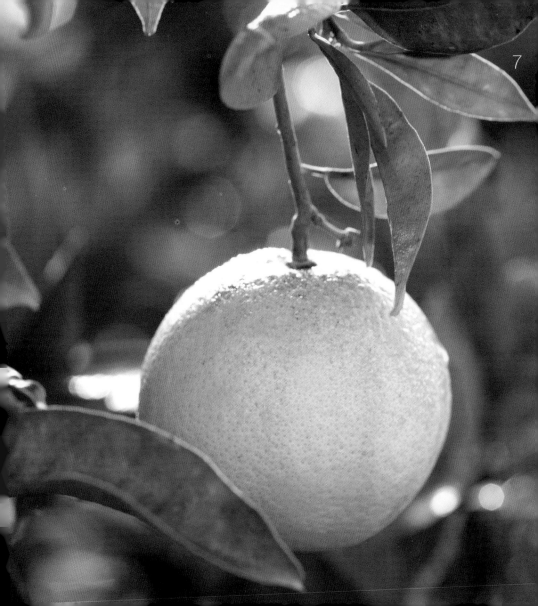

**7 Oranges.**
Majorcan oranges are small and very sweet. Orange production is important to the island's economy especially in and around the towns of Muro, Sa Pobla, Palma, Inca, Llubí and, especially, Sóller. In the case of the latter, the orange trees cover great expanses and when they are in blossom the entire valley is filled with the delicate scent of orange blossom. Part of the home grown orange production is set aside to make preserves and marmalade.

**8 Pa de figa.** A traditional and filling dessert. This traditional fig cake is made with figs, spices and dried fruits, to be eaten above all at Christmas time. In the past, besides being a sweet this also constituted an important source of energy for the peasant farmers who had to affront gruelling agricultural tasks.

**9 Dried red pepper.** Since its arrival from America, the pepper and its derivative paprika has become a major part of the island's gastronomy. The peppers are dried in the sun, afterwards to be ground into sweet or spicy paprika, a fundamental ingredient of *sobrassada* and many other dishes. In Pòrtol the peppers are still strung together and hung in the sun on the facades of stone houses. Once dried, they are finished in the oven prior to being ground. Unfortunately this is an image which is about to disappear with paprika production now almost entirely industrialised.

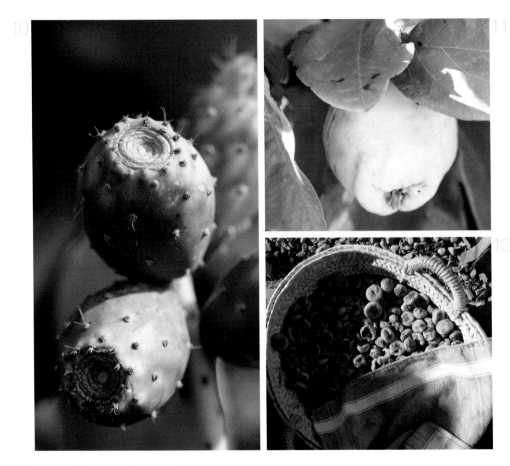

**10** Prickly pears. **11** Quince. **12** Dried figs.
**13** Peppers. **14** Pomegranate. **15** ricotta type cheese
(in Catalan, *brossat*),

### Other products.

Prickly pears, grapefruits and pomegranates are fruits of limited commercial value which the Majorcan people have lived on for centuries. Nowadays they are used to prepare excellent preserves. Also in Majorca there is a substantial cheese production, both from cows and sheep as well as ricotta type cheese (in Catalan, *brossat*) indispensable in some confectionery delights such as *robiols* or duchess cakes. The Majorcan vegetable garden maintains a constant output of vegetables both winter and summer, cabbage, spinach, chard, cauliflower, sweet or spicy red and green peppers, courgettes and aubergines, the latter being the main ingredient in dishes of Arab heritage such as stuffed aubergines. Also in abundance are fruits such as the apricot, peach, plum, orange, lemon, mandarin, melon, watermelon and the peculiar *gíngols* (jujube fruit). A colourful yield which inundates the weekly markets held in all Majorcan towns.

**16** Dried tomatoes. **17** Col.
**18** *Gíngols* (in Spanish, jujube fruit).

cooking_**mallorca**

# 01

**Serves four**

# starters

# bullit
# stew

* 250 g stewing beef * 250 g minced meat (equal amounts of pork and beef) * 1/4 chicken or fowl
* 1 *botifarró* * 50g *sobrassada* * 1/4 cabbage * 1/2 kg potatoes * 250 g green beans
* 2 medium carrots * 2 medium onions * 1 large turnip * 1 leek * 2 *ramellet* tomatoes or
1 medium ripe tomato * 75g pine nuts * 1 bay leaf * 1 sprig of fresh *moraduix* (marjoram)
* olive oil * salt

1. Firstly grind the pine nuts in a mortar and pestle and blend together with the minced meat and *sobrassada*. Next bind the mixture together in the form of a large oblong meatball. Wash the beef and place in a large pot, cover with plenty of water and once the water reaches boiling point simmer for 30minutes.

2. Next, add the chicken and meatball mixture, cook for a further 30 minutes. Whilst the meat is cooking, peel and wash the turnip, potatoes and carrots. Peel and quarter the onion. Scald the tomatoes, skin them, and once cooled cut into quarters.

3. Cut the vegetables and add to the pot together with the stewed meat. Season with salt, bay leaf and the sprig of fresh *moraduix* (marjoram). Simmer for a further 15 to 20 minutes. Check the vegetables are cooked before removing the pot from the heat. Sprinkle the stew with a splash of oil and serve.

This stew is prepared in different ways according to the seasons. In summer fresh haricot beans or *pochas* are used. The stew has for centuries been a part of the staple diet and corresponds to the dish known in Catalonia as *escudella i carn d'olla*.

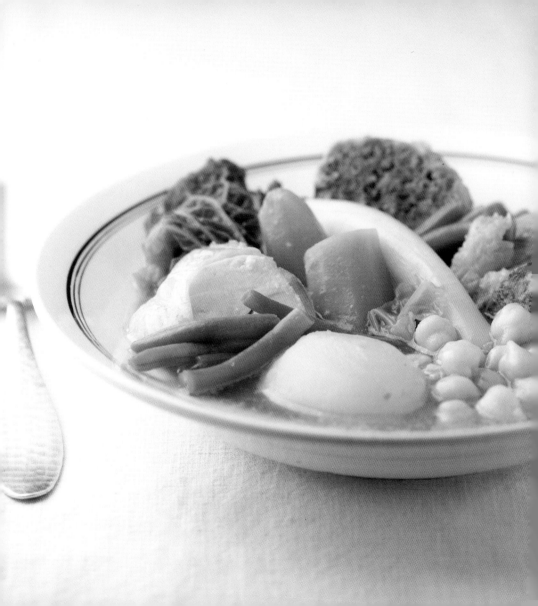

# sopes seques
# majorcan stew
## with bread

* 200g of *sopes* (finely sliced brown country bread sold ready sliced in the island's bakeries)
* 200g of lean chopped pork (optional) * 100g of *camaiot* or *botifarró* (optional) * 1/2 cabbage
* 1/2 cauliflower * 2 *ramellet* tomatoes or 1 medium ripe tomato * 2 onions * 2 cloves of garlic
* parsley * 1 1/2 dl olive oil * 2 cs sweet paprika * salt

1. Remove the hard centre of the cabbage and cut the rest into julienne strips. Break the cauliflower into small sprigs. Peel and chop the onion. Scald and chop the tomatoes. Crush the garlic.

2. Heat the oil in a *greixonera* or earthenware cooking pot and fry the garlic until almost burnt. Remove the garlic and brown the meat in the same pot adding salt and pepper. Once browned remove with a skimming spoon and put to one side. In the same oil prepare a *sofrito*: fry the onion for on a low light for ten minutes with a pinch of salt, add the chopped tomato and paprika and check for seasoning adding more salt if required.

3. Add the cabbage and the meats, cover with water. Check seasoning, bring to the boil and cook for 20minutes.Add the sprigs of cauliflower and cook for a further 10 minutes.

4. Lay the *sopes* or bread slices over the top of the *greixonera*. Remove from the heat and leave to rest until the bread has soaked up the stock and serve.

There are many variations of this recipe. The use of meat is optional but the slices of brown or black bread is an indispensable ingredient. Apart from that seasonal vegetables can also be used such as artichokes, spinach, chard, leeks, peas, etc.

# escudella fresca
# fresh escudella

* 1/2 kg *pochas* (fresh haricot beans) * 150 g green beans * 1/2 white cabbage * 2 medium potatoes * 3 medium carrots * 1 medium courgette * 1 large onion * 1 cs olive oil * 1 cc sweet paprika * freshly ground black pepper * salt

1. First of all shell the *pochas* (haricot beans). Next peel the onion and cut into julienne strips, wash the green beans, carrots and courgette. Quarter the cabbage removing the hard centre and cut into julienne strips, leave to drain in a colander. Trim and slice the green beans.

2. Peel and chop the carrots and or cut into slices 1.5cm thick. Wash, peel and dice the potatoes into 1cm cubes. Lastly trim and chop the courgette. Place the carrots, *pochas* and onion into a pot, cover with water and add a pinch of salt. Cook for 15 minutes.

3. Add, in the following order and at 5 minute intervals, the cabbage, beans, potatoes and finally the courgette. Check and rectify salt seasoning.

4. Add the sweet paprika and black pepper to taste, stir well with a wooden spoon and leave to cook a further 5 minutes. Remove from the heat and sprinkle the *escudella* with olive oil. Stir once more prior to serving.

*Escudella* is a traditional fresh vegetable soup usually only prepared in summer until the end of the *pochas* season in autumn. The rest of the year the vegetables are replaced by winter varieties such as cabbage. The word "*escudella*" comes originally from the name of the pot in which this soup was made.

# pa amb oli
# bread with olive oil

8 slices of round brown bread

4 *ramellet* tomatoes or medium sized ripe tomatoes

2 dl virgin olive oil

100 g Majorcan olives

pickled sea fennel (*fonoll marí*)

4 cs capers

salt

1. Slice the bread. Cut the tomatoes in half and rub into one side of each slice of bread. Season with salt and sprinkle with virgin olive oil.

2. Serve with pickles typical of the island: pickled sea fennel, pickled Majorcan olives and capers.

This is the simplest and most well known dish on the island. Basically, *pa amb oli* is literally just bread with olive oil and salt, unlike *pa amb oli i tomàtiga* (bread with olive oil and tomato). The tomato used in Majorcan bars and restaurants is the *ramellet*. This dish is served accompanied by the local pickles and cured meats or *embutits*.

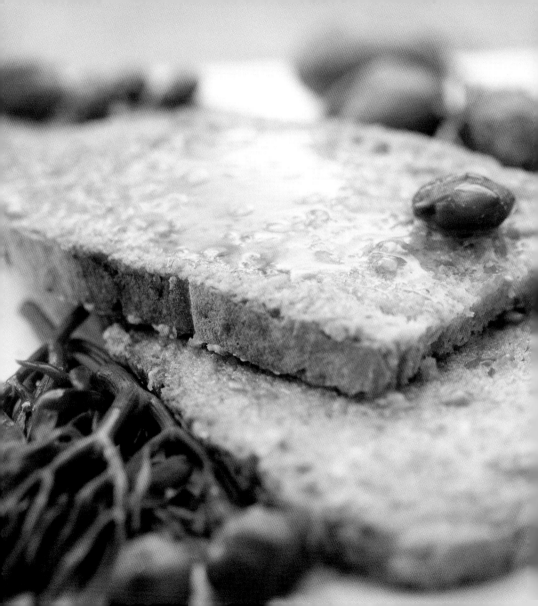

# colflori ofegada
# fried cauliflower

\* 1 cauliflower \* 200 g fresh pancetta \* 50 g *sobrassada* \* 1 *botifarró* \* 1 large onion
\* 2 *ramellet* tomates or 1 medium sized ripe tomata \* 25 g raisins \* 25 g pine nuts \* 4 garlic
cloves \* 1 bay leaf \* olive oil or lard \* 1 level tbsp paprika \* ground black pepper \* salt

1. Scald the tomatoes and leave to cool, remove the skins, seeds and finely chop. Peel the onion and very finely chop. Separate the cauliflower into small sprigs, wash and leave to drain in a colander.

2. Wash and cut the pancetta into small pieces. Heat 2 level tablespoons of oil or lard in a pan and once the oil or lard is hot, sauté the chopped pancetta, *botifarró* and *sobrassada*, stirring until browned. Next add the chopped onion, tomato, garlic cloves and bay leaf.

3. Once the *sofregit* mixture is well softened, add a cup of water, reduce the heat, cover the pan and leave to cook for 15 minutes, occasionally giving the pan a shake from side to side (in place of stirring the ingredients with a spoon).

4. Finally, add the cauliflower, raisins, pine nuts and paprika. Cover and leave on a medium light for 20 minutes, giving the pan a shake from time to time. Before removing from the heat, check seasoning and serve.

This cooking method of rhythmically shaking the pan from side to side is frequently used in Majorca. The movement itself is known as *sacsejar* (similar to the method used by the Basques to make *bacalao al pil-pil*, cod cooked in olive oil and garlic).

# tombet
# tombet

* 1/2 kg potatoes * 1 medium courgette * 2 medium sized red peppers * 2 medium sized aubergines * 1/2 kg ripe tomatoes * 2 garlic cloves * salt * ground black pepper * olive oil

1. Wash and dry the potatoes and vegetables. Peel the potatoes and slice or finely dice. Slice the aubergine and courgette with the skins intact. Scald the tomatoes and leave to cool before removing the skins and very finely chop.

2. Cut the peppers in half lengthways, remove the stalk and seeds and cut into small squares. Heat a splash of oil in a frying pan and fry the potatoes until browned. Remove with a skimming spoon and leave to drain on a plate covered with sheets of absorbent kitchen paper.

3. Fry each of the vegetables separately in the same way for approximately 10 minutes and leave to drain on plates covered with absorbent kitchen paper. In the same frying pan, make a sauce with the chopped tomato, chopped garlic cloves, salt and pepper to taste; leave to cook on a low light for 30 minutes, checking the acidity of the tomato and if necessary adding a pinch of sugar.

4. Line the bottom of an earthenware dish or *greixonera* with the potatoes. Then add, in this order, the aubergine, courgette, peppers, and lastly cover with the tomato sauce.

This is just one of many excellent *tombet* recipes, equally as good as a starter or a side dish to accompany meat or fish. A final touch to the recipe comes either from eggs ready cooked or beaten and added to the dish to be finished in the oven or alternatively with fish or meat (such as rabbit for example).

# albergínies farcides
# stuffed aubergines

* 8 small aubergines * 250 g minced meat (half and half pork and beef) * 50 g *sobrassada*
* 4 medium sized ripe tomatoes * 1 large onion * 2 garlic cloves * 3 sprigs of parsley * 1 sprig of
marjoram * 1 sprig of thyme * 100 g *galleta* picada or breadcrumbs * 2 eggs * 2 dl olive oil
* ground black pepper * salt

1. Bring some water to boil in a pan. Remove the stalk from the aubergines and cut in half
lengthways. Scald in the boiling water, remove with a spatula and leave to drain in a colander. Once
slightly cooled, remove the flesh leaving at least half a centimetre thickness inside the skin. Finely
chop the flesh and keep to one side.
2. Scald the tomatoes and leave to cool, skin and chop. Peel and chop the garlic. Peel and grate the
onion. Wash the herbs, remove the marjoram leaves and chop the parsley.
3. Heat half of the olive oil in a frying pan and sauté the meat with the marjoram, parsley, salt and
black pepper. Next add the aubergine flesh and the *sobrassada*, stirring well to mix the flavours.
When this is ready, remove from the heat and drain the filling in a Chinese colander.
4. Then add the onion and garlic to the meat, mix all together well and fill the aubergines. Next,
place on a oven tray and sprinkle with the *galleta picada*. Heat the oven to 160° C, trickle olive oil
over the aubergines and bake in the lower part of the oven.
5. Heat the remaining oil in a frying pan and make a sauce with the tomato, thyme, salt, and black
pepper. Cook on a low light for 30 minutes. Remove the sprig of thyme and pour the sauce over the
aubergines before serving.

In some cases stuffed aubergines are served without the tomato sauce. In others, the sauce is placed in a greixonera,
the aubergines placed on top and they are given a final blast of heat in the oven. The oldest European recipe for
aubergines appears in the 14th century Sent Sovi cookery book.

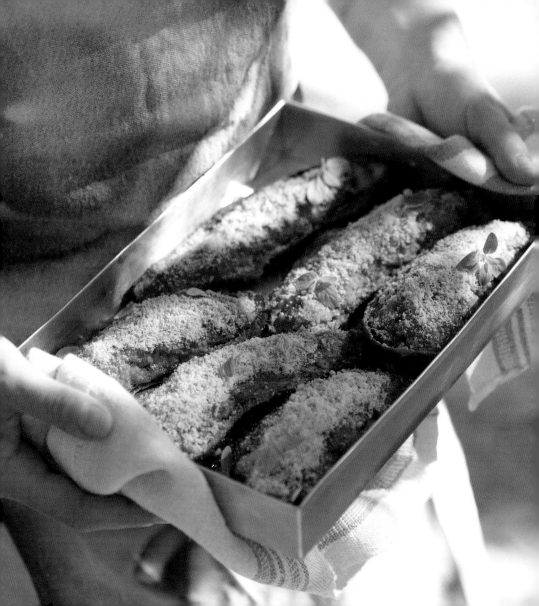

# trempó
# trempó

3 or 4 medium salad tomatoes
1/2 onion
1 spring onion
2 long green peppers
1 dl olive oil
2 cs wine vinegar (optional)
salt

1. If you prefer the tomatoes skinned they have to be first scalded for a few seconds in boiling water and once cooled, finally chopped. Next wash the peppers, remove the stalk, the middle, the seeds and cut into small squares. Peel the onion and spring onion.

2. Finely slice the onion and chop the spring onion. Mix all the vegetables together in a salad bowl and season with salt, stirring to mix the flavours.

3. The salad can be sprinkled with vinegar if so desired. Afterwards add the oil and stir again. Trempó is served with pickles such as cracked olives (*trencades*), capers or sea fennel (*fonoll mari*) and slices of brown bread.

*Trempó* is a simple summer salad. In some cases the spring onion is replaced by a well chopped garlic clove and in others apple or apricot is added. The most important factor is that the vegetables are well coated in olive oil to be able to make the most of the soaked bread.

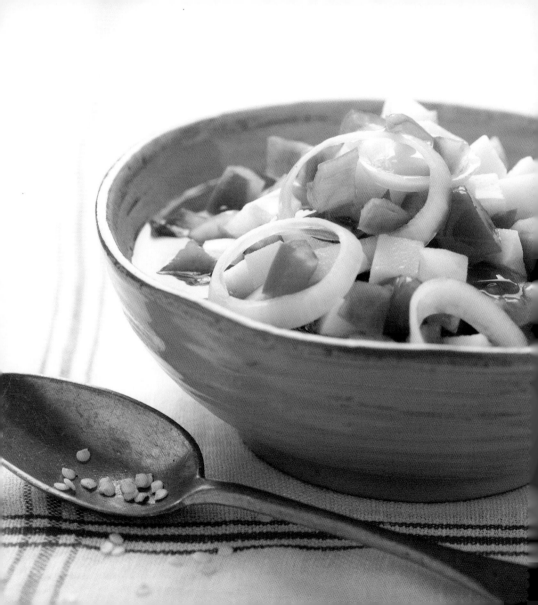

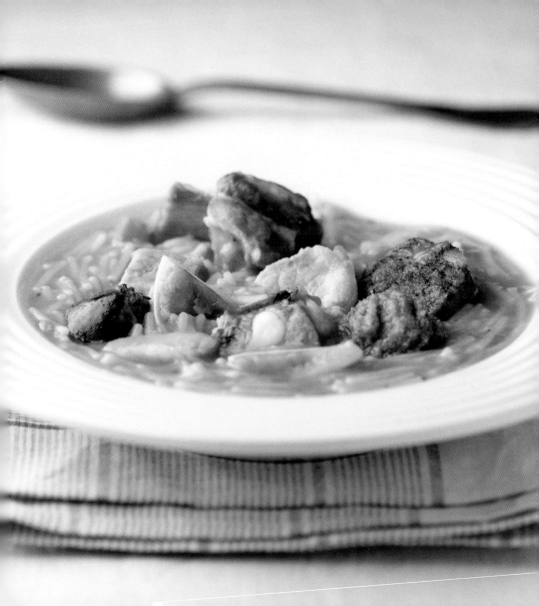

# fava parada
# broad bean stew

* 200 g dried broad beans * 250 g chopped pork spare ribs * 150 g fresh pancetta * 150 g pig's ear and snout * 1 *botifarró* * 2 onions * 3 *ramellet* tomatoes or 2 medium sized ripe tomatoes * 200 g vermicelli * 1 salted bone * salt * olive oil

1. Leave the dried beans to soak overnight in water at room temperature. Wash the meat and bones, dice and cook in a deep pan with plenty of water until cooked and tender (1 hour approximately).

2. The following day peel and chop the onions. Scald the tomatoes for a few seconds, leave to cool, remove the skin and seeds and chop.

3. Put the onion and chopped tomato in a saucepan together with the beans. Cover all with the previously filtered cold meat stock. Cook the stew until the beans start to break up.

4. Next add the chopped meat and the *botifarró* sliced.

If the soup becomes too thick, check for salt and add more meat stock. Bring to the boil and immediately add the vermicelli and a good dash of olive oil.

5. Continue to cook, continually stirring with a wooden spoon, until the vermicelli is cooked. Check and address the seasoning. Stir well before removing from the heat and serve.

This broad bean stew type dish shouldn't to be too thick. Dried beans are an age old source of subsistence food in the Mediterranean and this stew is one of the basic recipes used by peasant farmers in the rural Majorca of old, above all in the winter.

# granada d'albergínies
# aubergine granada

* 600 g of aubergines * 125 g of chopped beef and pork mixed (optional) * 5 eggs * 1 large onion
* 0.5 dl milk * 100 g red peppers * 0.5 dl olive oil * butter to grease the baking tin
* freshly ground black pepper * salt

1. Preheat the oven to 175º C. Grease the inside of a 1 litre baking tin using kitchen paper impregnated with butter.

Wash, dry and cut the peppers in half, remove the seeds and quarter. Without peeling, dice the aubergines and leave to soak in a bowl of salted water for 15 minutes.

2. Heat the oil in a pan and sauté the onion for 3 minutes with a pinch of salt. Add the pepper and sauté for a further 10 minutes on a higher heat. Add the meat, stir well and fry all together on a low light for 3 minutes.

3. Wash and drain the aubergines, add to the pan, season with salt and pepper and cook for 10 minutes on a high heat. Beat the eggs and milk together, turn off the heat and add to the vegetables and meat.

4. Check and if need be rectify the salt and pepper content. Pour all into the baking tin and cook in the centre of the oven for 35 to 40 minutes. To check if cooked, spike the centre with a rod which should, if sufficiently cooked, come out clean. Leave to cool slightly and remove from the baking tin.

This recipe is served accompanied by strips of browned red peppers and tomato sauce seasoned with bay leaf, salt and black pepper. Traditionally the recipe is prepared without meat. This is actually a celebration dish from medieval times of clearly Arabic influence. This dish can be served either hot or at room temperature.

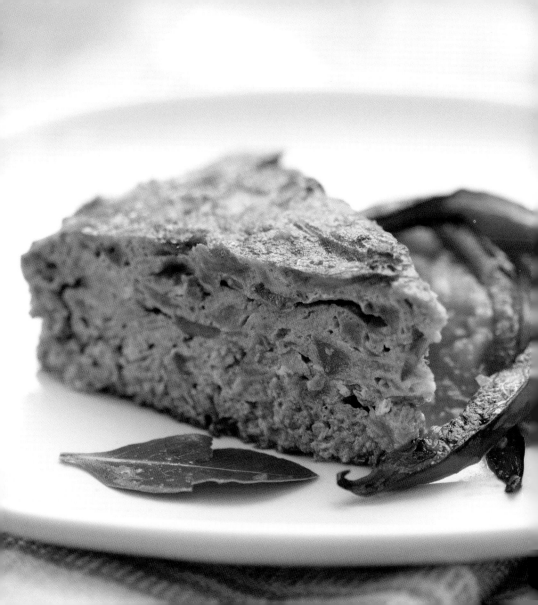

# arròs brut
# brut rice

* 4 coffee cups rice * 1 small cuttlefish * 1/4 chicken chopped * 200 g lean pork chopped
* 200 g pork chops chopped * 200 g rabbit chopped * 1 rabbit liver * 50 g *sobrassada* * 100 g
chanterelle mushrooms (optional) * 100 g green beans * 100 g mangetout * 2 artichokes
* 1 red pepper * 3 medium tomatoes * 1 medium onion * 2 garlic cloves * 2 sprigs of parsley
* 1 dl of oil and lard (optional) * ground black pepper * saffron * salt

1. Peel and chop the onion and garlic. Clean the mushrooms and wash the vegetables. Slice the
beans and peppers. Peel and cut the artichokes. Remove the stalks and string from the mangetout.
Scald the tomatoes, leave to cool slightly, skin and chop. Wash the meat. Clean the cuttlefish and cut
into pieces. In a saucepan, heat up 10 coffee cups of water or stock.

2. In a large frying pan, heat 1decilitre of olive oil and lightly fry the meats, seasoned with salt and pep-
per, until well browned. Next, add the onion and cuttlefish, stir well and add the chopped tomato and a
pinch of pepper. Cook for 10 minutes.

3. Next, add the vegetables, salt, stir well and cover with the water. Immediately after add the rice and
leave to cook for 20 minutes. In the meantime, crush the garlic in a mortar and pestle together with a
pinch of saffron, the parsley leaves washed, the liver, chopped, and the *sobrassada*, thin the mixture
with a little hot water, add to the rice and continue to cook until ready.

Another recipe in which the ingredients used are literally what is currently available. Most commonly made with meats
and *embutits* but, depending on the area, cuttlefish or chanterelles (*picornells* in Catalan) are added if in season. In
the hunting season pigeons or thrush are often used and also a great favourite is brut rice with rabbit

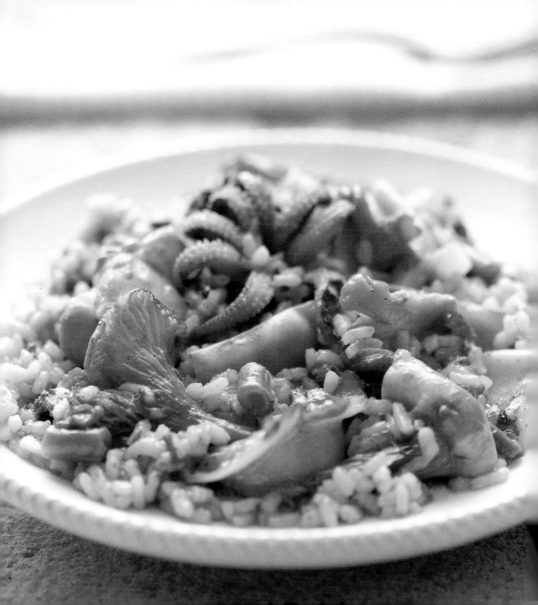

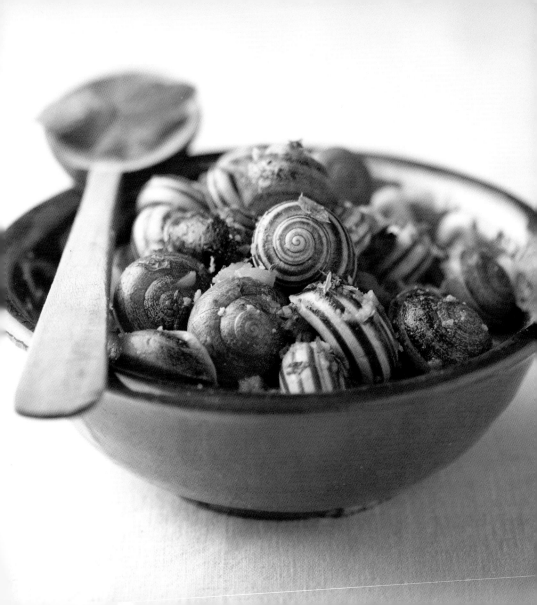

# caragols cuinats
# snail stew

* 4 dozen purged snails * 50 g *sobrassada* * 100 g camaiot * 50 g bacon fat * 2 onions
* 4 garlic cloves * 4 ripe tomatoes * 2 sprigs of fresh parsley * 2 sprigs of fresh mint * 2 sprigs of fresh marjoram * 1 sprig of dried river basil or Santa María * sprig of dried lemon balm or a piece of orange rind * 1 dried sprig of fennel * 1 dl milk * 1 dl olive oil * 1 chilli * salt

1. Wash the snails well. Place in a pot with cold water and heat on a medium light counting five minutes cooking time from the time it starts to boil. Then strain the snails and throw away the cooking water. Heat some water in a pot and add the sprigs of fresh herbs washed as well as the dried herbs.
2. Peel two garlic cloves and an onion. Wash and cut the tomatoes in half and add to the pot. Then add the snails and cook for two hours. In the meantime scald the remaining tomatoes and once cooled, skin and chop. Peel and chop the second onion and the remaining garlic cloves.
3. Heat the oil in a frying pan and prepare a *sofregit* with the onion, garlic and chopped tomatoes. Add the chopped meat and the chilli. When the snails are cooked, drain and save a small glass of stock. Add the snails to the *sofregit*, then the milk and finally the stock. Cook for a further 10 minutes.

Some very famous snails are served at festival time in Sóller. Etiquette is completely forgotten and they are eaten literally by sucking from the fingers. In Majorca it is still a habitual practice to go out collecting snails after the rain.

cooking_**mallorca**

# 02

**Serves four**

# meat and fish recipes

# greixonera d'anguiles
# stewed eel

* 1 kg chopped eel * 2 *ramellet* tomatoes or 1 medium sized ripe tomato * 3 garlic cloves
* 2 fresh spring onions or leeks * 4 small potatoes * 1 egg * 3 or 4 artichokes * 150 g peas
(optional) * 4 almonds * 6 sprigs of parsley * salt * freshly ground black pepper * paprika
* bay leaf

1. Wash the pieces of eel well. Peel the garlic cloves and spring onions and chop separately. Scald the tomatoes, leave to cool, skin, remove the seeds and finely chop. Wash and dry the parsley, remove the leaves and very finely chop. Boil the egg, cool and remove the shell. Peel and slice the potatoes.

2. Place the pieces of eel in a bowl and season with 1/3 of the chopped garlic, a pinch of parsley, black pepper and paprika according to taste and a dash of oil. Stir well by hand and leave the eel to macerate for at least 20 minutes.

3. Heat 2 or 3 table spoons of oil in a *greixonera* or earthenware cooking dish and prepare a *sofregit* with the chopped onion and tomatoes, half the garlic and the remaining parsley. Once this is all well softened add the potatoes. Stir well and cover with water, add a pinch of salt and cook for 10 minutes. In the meantime, peel and cut up the artichokes.

4. Once boiling point is reached, add the pieces of eel together with the marinade, the artichokes, peas and the bay leaf. Stir well and cook for 10 minutes more.

5. Mix together the egg yolk, almonds and the remaining garlic. Prick the artichokes with a rod to check if tender and therefore cooked. If so add the egg mixture diluted by a little stock. Stir, check the salt and serve.

This dish is typical of Sa Pobla, the only place on the island where eels are found. As always, the recipe varies from one household to another and also according to the vegetables available with respect to the time of year.

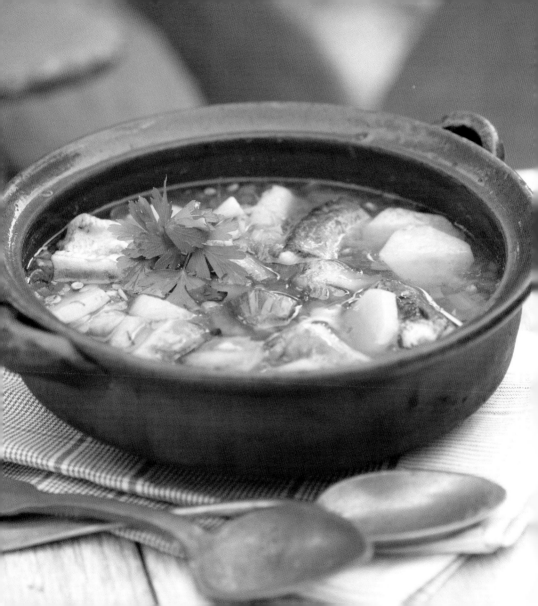

# calamars farcits
# stuffed squid

* 1 kg squid * 250 g minced meat (half beef, half pork) * 4 medium sized ripe tomatoes * 1 large onion * 2 eggs * 3 garlic cloves * 3 sprigs of parsley * 1 sprig of marjoram * 2 dl white wine * 6 cs olive oil * flour * ground black pepper * salt

1. Clean the inside of the squid, leaving the skin. Chop the tentacles and fins. Scald the tomatoes and leave to cool, remove the skins and finely chop. Peel the garlic and chop two of the cloves. Wash and dry the herbs. Remove the parsley leaves and chop. Peel and very finely chop the onion.

2. Cook one of the eggs for 8 minutes, cool, shell and finely chop. Next heat two table spoons of olive oil in a frying pan and when it is hot gently fry the onion for 10 minutes with a pinch of salt. Remove from the heat and set aside.

3. Mix the chopped squid with the minced meat and add the onion, parsley, garlic, the chopped egg and finally a pinch of both marjoram and salt. Beat the second egg, add to the mix and stir all well together. Stuff the squid with this paste and close with a cocktail stick.

4. Flour the squid. Add the rest of the oil to the frying pan and fry the squid on a low light for 15 minutes, until browned on all sides. Remove with a spatula and place in a *greixonera* or earthenware cooking pot.

5. Use the same oil used to fry the squid to make a sauce by simmering together, on a low light, the tomato pulp together with a garlic clove, the remaining marjoram, a pinch of salt and, if the tomatoes are sour, a pinch of sugar.

6. Pour the sauce over the squid. Heat the *greixonera*, add 1 dl of water, the wine, and finish off by cooking on a low light for 15 minutes.

This dish is usually served with a side plate of small fried potato chunks and is an excellent example of "sea and mountain" gastronomy, which combines fish and meat. Similar dishes have appeared in medieval recipe books made with octopus and cuttlefish.

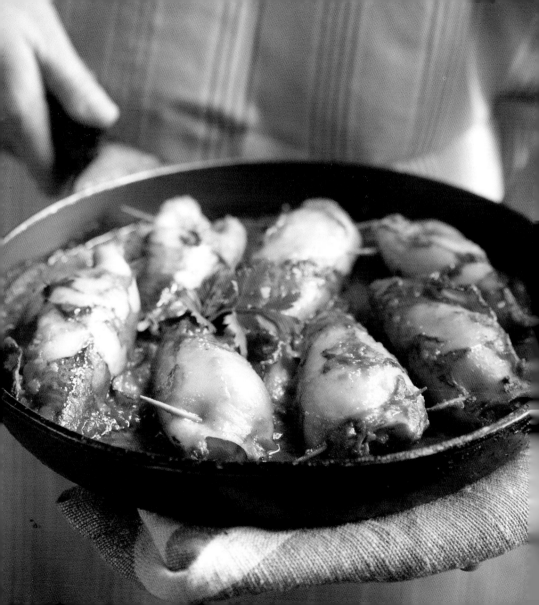

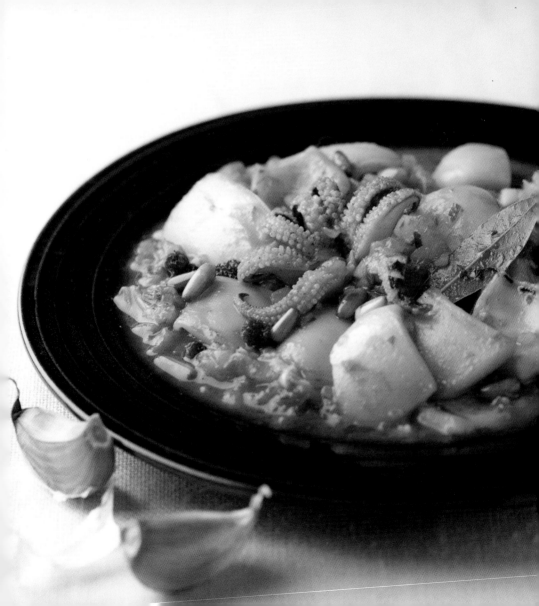

# sípia amb ceba
# cuttlefish with onion

* 1 kg sepia * 2 kg onions * 2 *ramellet* tomatoes or 1 medium sized ripe tomato * 2 tbsp pine nuts * 2 garlic cloves * 4 cs raisins * 50 ml olive oil * 1 bay leaf * 1 level cs sweet paprika * 0.75 dl brandy * freshly ground black pepper * salt

1. Clean the cuttlefish, removing the skins, viscera and cartilage from the inside. Remove the eyes and set aside the tentacles. Cut the heads into 3 or 4 cm cubes. Chop the tentacles. Wash and dry the raisins.

2. Peel and slice the onions into fine julienne strips. Scald the tomatoes for a few seconds in boiling water and leave to cool before removing the skins and chopping. Peel and chop the garlic.

3. Pour half the oil in a pan and heat. Add the cuttlefish, garlic and bay leaf, cover and simmer on a very low light for 15 minutes.

4. Add the rest of the oil together with the tomato, cook for 2 minutes more and add the paprika and onion strips. Stir and cook for a 5 minutes more.

5. Add the brandy, raisins and pine nuts. Check the salt and cook for 25 minutes. Served warm.

This recipe contains pine nuts which in Majorcan gastronomy, as is also the case with almonds, are not usually browned before adding to stews. Cuttlefish stews usually require slow cooking in order to become tenderised and incorporate the flavour of the accompanying ingredients.

# llampuga amb pebres vermells
# common dolphinfish with red peppers

* 1 kg common dolphin fish cut into thick slices * 3 red peppers * 2 ripe tomatoes * 4 garlic cloves * 2 onions * 2 bay leaves * 1 dl white wine * flour * olive oil * ground black pepper * salt

1. Peel and chop the onion. Scald the tomatoes in boiling water and once cooled a little, remove the skins and chop.
Crush two garlic cloves and chop the remaining. Remove the stalks, the centres and the seeds from the peppers cut into pieces. Peel and chop the onions.
2. Make a tomato sauce: heat four table spoons of olive oil and once hot fry the onion with a pinch of salt for 10 minutes, stirring occasionally. Add the chopped garlic, bay leaves and chopped tomato. Season with salt and pepper and if the tomato is very sour add a pinch of sugar. Leave to simmer for 20 minutes.
3. Heat the oil in an earthenware cooking pot and brown the crushed garlic. Remove the garlic with a skimmer. Using the same oil, sauté the peppers until slightly browned, remove from the oil and set aside.
4. Flour the pieces of fish, tapping lightly to remove any excess flour. Next fry the fish in the oil. To serve, pour the tomato sauce into a *greixonera* or earthenware pot, next the pieces of fish and lastly place the fried peppers on top.

The common dolphinfish is one of the most popular fish on the island. In Spanish it s known as the *lampuga* or *dorado* and in tropical seas is known to weigh up to 40kg. It has a beautiful bluish green colour with a distinguishing yellow stripe on the sides.

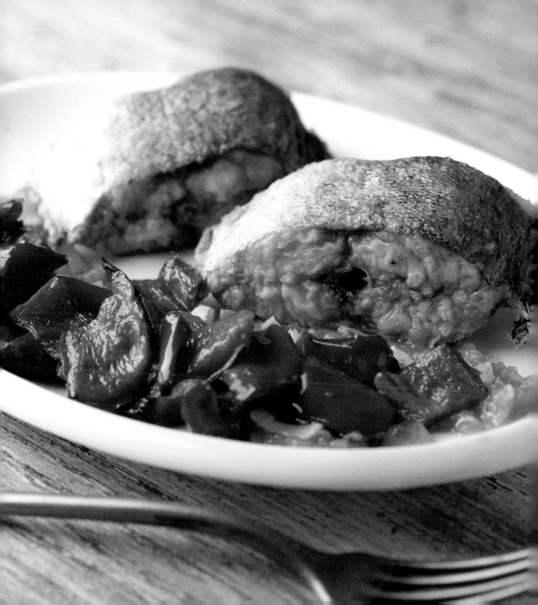

# peix al forn
# baked fish

\* 1 1/2 kilos denton, pandora, common dolphin-fish, grouper or any other large clean fish
\* 6 medium potatoes \* 1 bunch spinach \* 1 bunch chard \* 2 large ripe tomatoes \* 4 cloves of garlic \* 1 bunch spring onions \* 2cs pine nuts \* 50g raisins \* 1 lemon \* 4cs *galleta picada* or breadcrumbs \* 1 dl olive oil \* 1 level cs paprika \* freshly ground black pepper \* salt \* sprig parsley

1. Wash the fish inside and out, season with salt and pepper and sprinkle with the paprika. Make a juice from the fresh lemon and sprinkle over the fish, leave to macerate for a few minutes. Peel and cut the potatoes into slices of a medium thickness and spread over the base of an oven dish.

2. Remove the spinach and chard leaves from their stalks, wash, drain and chop separately. Scald the tomatoes for a few seconds, peel and chop. Peel the garlic, remove the shoot and chop.

3. Heat the oven to 160°. Using a mortar and pestle blend together the tomatoes and garlic, add salt and the olive oil, mixing all together well. Lay the fish over the potatoes and sprinkle with the tomato mix. Bake for around 15 minutes.

4. Peel and finely chop the spring onions and mix with the rest of the vegetables, parsley, raisins and pine nuts. Season with salt and pepper and a pinch of paprika and a good dash of olive oil, mix all together well and use to cover the fish. Lastly sprinkle with the breadcrumbs.

5. Cover the oven dish with baking foil or baking paper and bake for a further 20 minutes. Remove the paper and leave to bake for a further 10 minutes, to brown the vegetables.

*Galleta picada* is something frequently used in traditional Majorcan cookery, similar to breadcrumbs but made from *galletas de Inca*, a type of crispy biscuit made from bread and olive oil which are crushed almost to a powder.

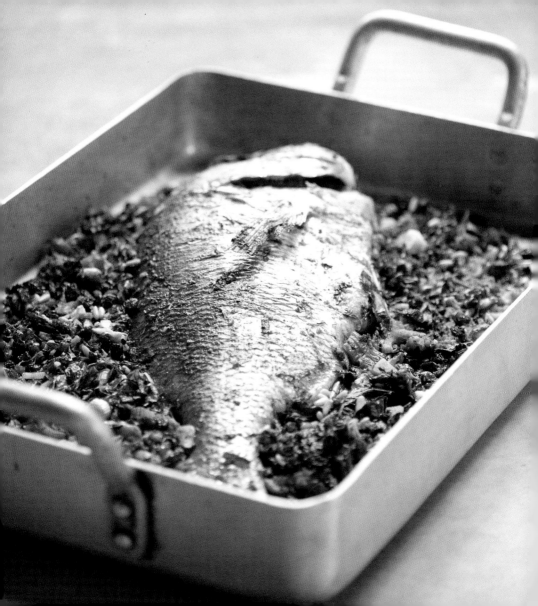

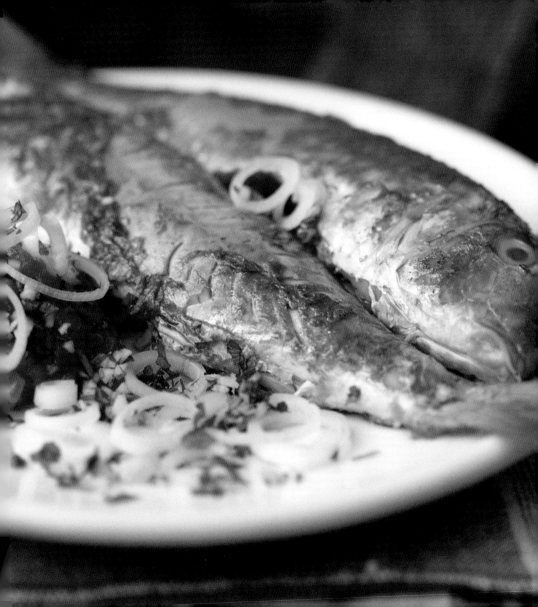

# molls amb tomàtiga
# red mullet with tomato

* 4 large red mullet * 8 *ramellet* tomatoes or 4 medium sized ripe tomatoes * 1 bunch of spring onions * 1 dl olive oil * 6 sprigs of parsley * 1 garlic clove * freshly ground black pepper * salt

1. Clean the fish thoroughly, removing the scales and, cutting down from beneath the head, remove the guts and liver.

Wash and dry the fish and season with salt and pepper inside and out. Remove the first layer and the darkest leaves from the spring onions and finely slice up to the middle of the stalks. Peel and chop the garlic. Wash dry and chop the parsley.

2. Wash and dry the tomatoes. Heat a non stick frying pan and fry the tomatoes without oil, turning over with tongs to ensure they are browned all over. Put the tomatoes into a soup dish and cover with another, leaving to cool at room temperature. Once cool skin, chop and season with salt and pepper. Place on a platter ready to serve.

3. Sprinkle the chopped spring onion over the tomato. Heat a splash of oil in the frying pan and brown the red mullet 2 minutes on each side. Lay on top of the layer of tomato and spring onion,

4. Sprinkle with the garlic and chopped parsley and quickly sprinkle over the rest of the oil.

This dish can be served cold or hot. There are similar recipes in Provence, Corsica, Greece, Turkey and Italy. Just lately red mullet has become very popular amongst the great chefs who now use this versatile, nutritious and reasonably priced fish in their most innovative recipes.

# escabetx de ratjada
# ray in escabetxats

* 1 kg ray skinned and cut into pieces * 2 medium carrots * 100 g cauliflower * 1 large onion
* 2 artichokes * 1 head of garlic * 2 bay leaves * 1 dl vinegar * 1 dl white wine * 1 dl olive oil
* 1 level cs sweet paprika * 1 level cs ground black pepper * salt

1. Peel and finely slice the carrots and the onion. Remove the hard outer leaves from the artichokes until coming to the softest leaves, remove the tips and cut into quarters or fine slices.

2. Separate the cauliflower into small sprigs, wash well and leave to drain in a colander.

3. Heat the oil in a frying pan. Flour and season the fish with salt and pepper and fry in the hot oil without browning.
Remove with a spatula and place in a *greixonera* or earthenware cooking dish.

4. Using the same oil, brown the garlic, lower the heat and add the onion. After 10 minutes add the carrots, season with salt and pepper and sprinkle over the vinegar and wine and add 1 decilitre of water. Add the cauliflower and bay leaves and cook for a further 15 minutes.

5. Remove from the heat, leave the *excabetxats* marinade to cool and pour over the fish. Cover and leave to rest for one day before eating the stew.

This recipe can be prepared with different fish also indigenous to and much appreciated on the island, such as the *gató* (dogfish) and the *mussola* (soupfin shark), although small sharks are unfortunately becoming increasingly scarcer in the Mediterranean.

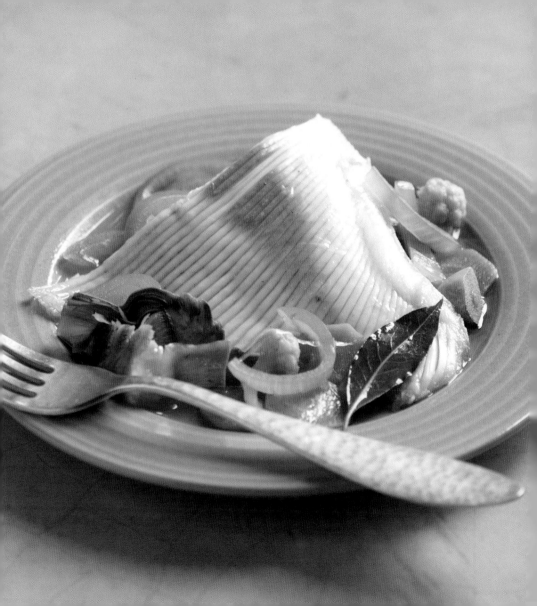

# aguiat de peix
# fish stew

* 6 pieces of monkfish * 800 g potatoes * 200 g fresh or frozen peas * 1 bunch of fresh spring onions * 6 *ramellet* tomatoes or 3 medium sized ripe tomatoes * 1 level tbsp sweet paprika * 1 dl white wine * 1 piece of lemon rind * 4 cs virgin olive oil * 1 bay leaf * 1 sprig of fresh *moraduix* (marjoram) * ground black pepper * 25 g *sobrassada* * 1 cs pine nuts * 2 garlic cloves * 4 Majorcan green olives (optional) * 3 small sprigs of parsley * salt

1. Peel the spring onions, remove the greenest part and slice the white part into julienne strips. Scald the tomatoes for a few seconds in boiling water, leave to cool slightly, remove the skins and chop. Peel the potatoes. Wash the lemon and remove the rind.

2. Heat the oil in a *greixonera* or earthenware cooking pot and make a *sofregit* with the spring onions and the tomato. Afterwards, add the paprika, lemon rind and the bay leaf. Stir well with a wooden spoon and season with salt and pepper. Next, add the wine and 3 decilitres of water. Add the potatoes whole and cook for 10 minutes.

3. Add the peas and cook for a further 5 minutes. Introduce the fish. In a separate frying pan, heat well, without oil, and fry the *sobrassada*. Chop separately the de-stoned olives, washed parsley leaves and peeled garlic and set aside.

4. Remove the skin from the *sobrassada*. In a mortar and pestle, blend together the pine nuts, chop and add the remaining ingredients and finally the *sobrassada*. Mix all into the stew and bring to the boil before serving.

This stew is prepared in a *greixonera* or fairly deep round earthenware cooking pot, one of the island's most used kitchen utensils. Monkfish is a delicious fish with a firm flesh, suitable for many cooking methods, even though it is usually rather pricey.

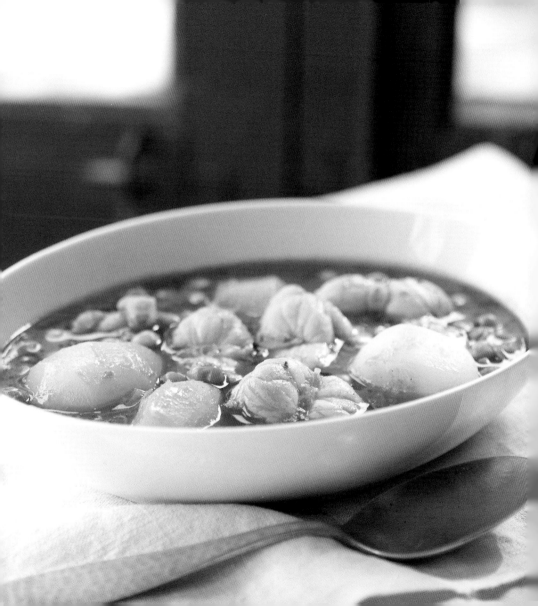

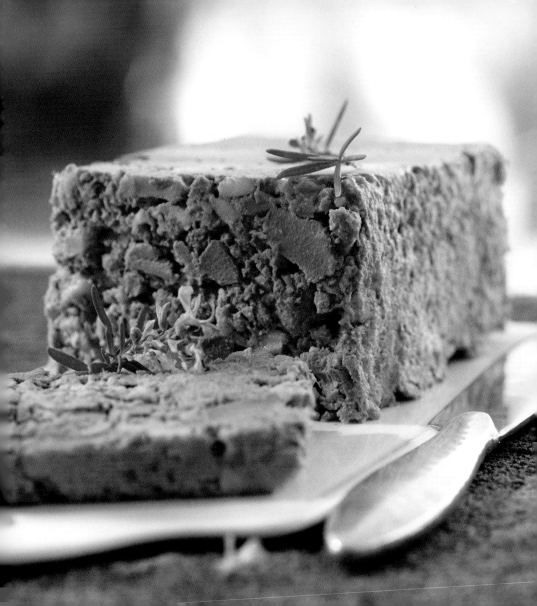

# pasta de fetge
# pork liver paté

* 1/2 kg pork liver * 1/2 kg lean chopped pork * 1/2 kg fresh pancetta * 1 level cc ground nutmeg
* 1 level tsp ground black pepper * 0.5 dl sherry * 0.5 dl brandy * 25 g truffle (optional) * 1 level cs
table salt

1. Remove the most visible sinews from the liver and chop into the smallest pieces possible. After removing the rind, repeat the same operation with the pancetta.

2. Mix the meat with the pancetta and liver in a deep bowl and season all with the salt and spices, stirring well.

3. Add the brandy and, if desired, the truffle finely chopped with its juice. Stir the entire mix once more. Heat a large saucepan with water and put the mix in a smaller pan.

4. Cook the pate bain-marie style by placing the smaller pan inside the larger, making sure the water doesn't boil over and wet the pate.

5. Cook on a low light for two hours, stirring often. Once ready, pour the pate into small ceramic or glass terrines.

Compress well by pressing down with a spatula. This pate needs to be left for one or two days before eating.

A Majorcan version of foie gras. If this paté is to be kept, the containers must be sterilised beforehand and afterwards cooked in a deep saucepan with boiling water.

# frit de matances
# slaughter fry up

* 300 g lean pork * 300 g pigs liver * 200 g fresh pancetta * 2 red peppers * 500 g potatoes
* 1/2 head of garlic * 1 bay leaf * 1 chilli * olive oil or lard * salt * ground black pepper

1. Wash and cut the peppers in half lengthways, remove the stalk and seeds and cut into medium sized squares. Next peel and cut the potatoes into long strips as if preparing French fries

2. Wash the pancetta, dry on absorbent kitchen paper and cut into small cubes. Also dice the liver and pork. Separate the garlic cloves and remove the first few layers of skin, leaving only the last layer.

3. In a deep frying pan or *greixonera*, heat a tablespoon of oil or lard and sauté the diced pancetta. Once slightly browned add a little oil.

3. Once the oil is hot, add the lean pork and the liver, garlic cloves, bay leaf and chilli and season all with salt and pepper to taste. Sauté the ingredients for a few minutes. In a separate frying pan sauté the red peppers and the potatoes in plenty of hot oil.

4. Mix all the ingredients together and check the salt, rectifying if need be. Sauté all together for a few minutes and serve hot or warm.

This is one of many existing fry up recipes, a dish which was traditionally prepared the same day as the pig slaughter. The combinations are numerous and it's not uncommon to find recipes which include such as chicken thighs or giblets, various vegetables, octopus or shellfish, etc.

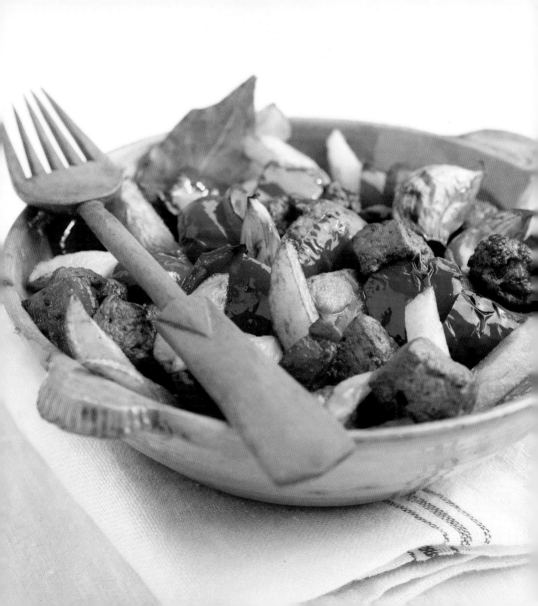

## porcella rostida
# roast suckling pig

1/4 suckling pig

2 cloves garlic

2 lemons

50 g lard

2 dl olive oil

2 level cs ground black pepper

1 level cs salt

1. Ask the butcher to score the suckling pig on the inside to make things easier afterwards. Clean the meat well inside and out.

2. Prepare a marinade: First juice the lemons. Mix together in a bowl the olive oil and garlic cloves finely chopped (if necessary cut in half lengthways and remove the shoot). Season with salt and pepper and add the lemon juice. Mix together well.

3. Season each cut made in the suckling pig by the butcher with spoonfuls of the marinade as well as the rest of the meat inside and out. Place the suckling pig in a deep oven dish and leave to marinate for a few hours.

4. Turn the meat, with the skin on the outside, and leave to stand overnight.

5. The following day, remove all the juice from the dish and spread the lard over the suckling pig's skin.

6. Preheat the oven for 10 minutes to 180°C. Place the dish into the oven and roast the suckling pig for one hour in the lower part of the oven. Before removing, check the meat is cooked; the skin or crackling should be brown all over and very crisp.

Roast suckling pig is usually served accompanied by roast potatoes (small potatoes grown above all in Sa Pobla and cooked in their skins) and/or green salad. The secret of the best suckling pig is to be roasted in a wood burning stove, one of the specialities of the popular *cellers* (former bodegas now converted into restaurants).

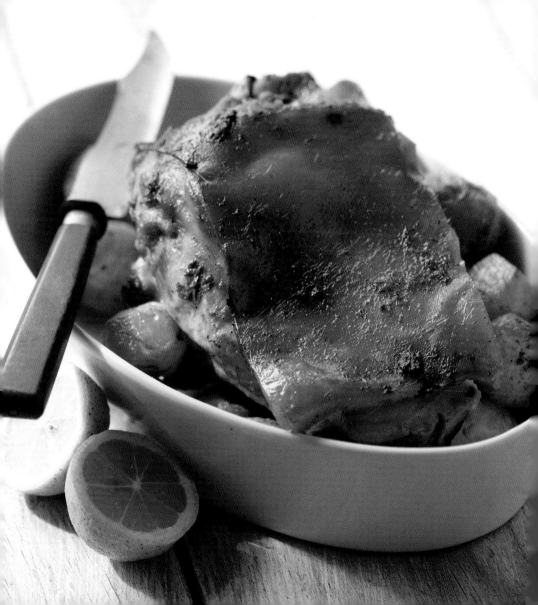

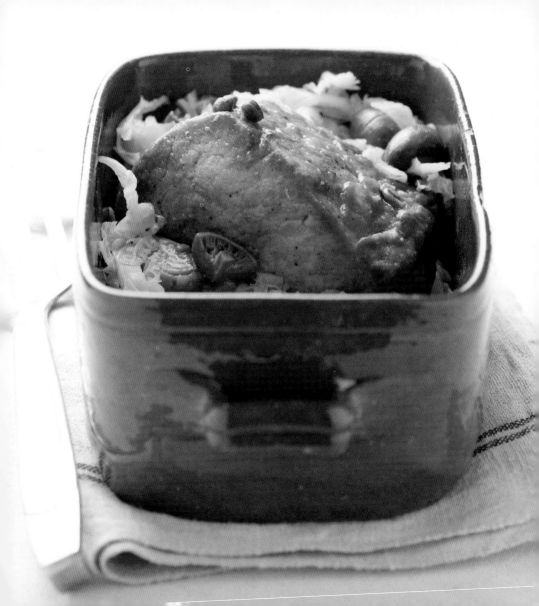

## llom amb col
# pork loin with cabbage

* 500 g pork loin sliced * 400 g cabbage leaves * 250 g saffron milk caps (optional) * 1dl olive oil
* 2 medium tomatoes * 2 medium onions * 1 rasher of pancetta * 1 *botifarró*
* 50 g *sobrassada* * 2 dl dry white wine * 1 bay leaf * 1 sprig fresh marjoram (or 1 teaspoon of dried marjoram) * 20 g pine nuts * 50 g raisins * paprika * ground black pepper * salt

1. Peel and chop the onion and wash the marjoram. Scald the tomatoes, skin and finely chop. Remove the heart of the cabbage, wash and drain the leaves.

2. If to be used, wash and dry the mushrooms. Chop the *sobrassada* into small pieces, slice the *botifarró* and dice the pancetta. Season the pork loin with salt and pepper.

3. Over a cabbage leaf, lay a slice of pork followed by two pieces of *sobrassada*, two slices of *botifarró* and two pieces of pancetta. Close the parcel and place on top of another cabbage leaf, with the opening downwards. Close the parcel once again and secure with a cocktail stick.

4. Heat half of the oil in an earthenware cooking pot. Once the oil is hot, brown the cabbage parcels on a high heat for one minute either side. Remove from the dish and set aside.

5. Add the rest of the oil to the cooking pot and soften the onion on a low light for 7 minutes. Next add the chopped tomato, saffron milk cups (optional) and the rest of the pancetta, *sobrassada* and *botifarró*. Afterwards add the paprika, bay leaf, marjoram, raisins and pine nuts, season with salt and pepper and leave to cook for 5 minutes more without turning the heat up.

6. Next add the pork cabbage parcels and sprinkle with the wine and sufficient water to cover the contents of the casserole dish. Cover and cook for 20 minutes more, before serving with the sticks removed from the parcels.

There are many variations on this recipe. Saffron milk cups are particularly popular in Majorca where they are known by the name of *esclata-sangs*. One creative version of the recipe is to prepare the dish with the pork loin piece intact and wrapped, the cabbage afterwards served as a garnish.

# conill amb ceba
# rabbit with onion

* 1 large rabbit cut into pieces * 1 1/2 kg onions * 1/2 lemon * 10 g *sobrassada* * 8 roasted Marcona almonds * clove garlic * 1 small sprig of parsley * 1 dl white wine * 1 dl olive oil * 1 bay leaf * freshly ground black pepper * 1 cc paprika * 1 pinch of *moraduix* (marjoram) * 1 pinch of nutmeg * 1 clove * salt

1. Juice the lemon. Peel the almonds. Remove the fat from the rabbit and cut into pieces, season with salt and pepper, place in a bowl sprinkle with the lemon juice, leave to soak a while. Peel and slice the onion into Julienne strips, Peel and chop the garlic. Wash, dry and finely chop the parsley.

2. Brown the *sobrassada* and half of the rabbit liver in a hot frying pan. Remove the skin from the *sobrassada* and blend together with the peeled almonds, garlic and chopped parsley in a mortar and pestle.

3. Heat the oil in a *greixonera* or earthenware cooking pot and brown the meat for between 5 to 7 minutes. Remove from the pot with a skimmer and set aside. In the same oil soften the onion with a pinch of salt for 25 minutes, stirring occasionally.

4. Add 1 cc of páprika, 1 pinch of nutmeg and 1 clove. Next add the rabbit, wine, the bay leaf, a pinch of *moraduix* (marjoram) and 1 small glass of water. Cover and cook the stew for 35 minutes on a low light.

5. Add a drop of stock from the stew to the mixture in the mortar and pestle, add to the rabbit and cook for a further 5 minutes.

This stew is prepared in a *greixonera* or earthenware cooking pot. As is the case with all stews, it is tastier if left to stand for a day. Serve with French fries. The rabbit can, as an option, also be marinated the night before in a combination of salt, black pepper, lemon and oil.

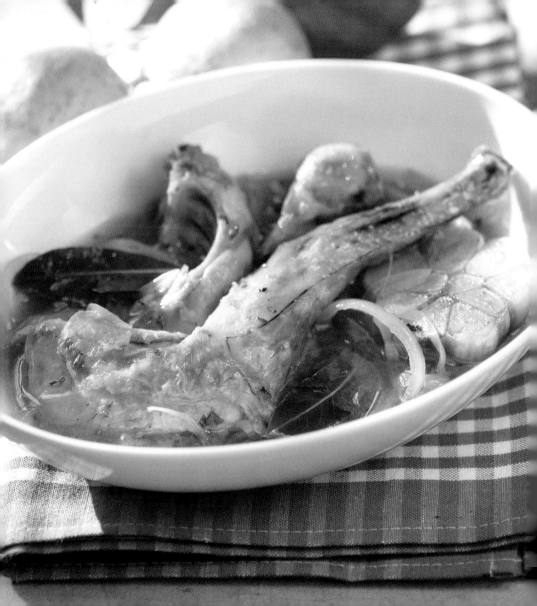

# fideus de veremar
# grape harvest vermicelli

* 1/2 kg lamb or mutton * 2 or 3 *ramellet* tomatoes or 2 medium sized ripe tomatoes * 1/4 kg onions * 400 g vermicelli * oil * salt * ground black pepper * lamb bones

1. Wash the lamb bones and use to make two litres of stock. Trim the fat from the lamb, wash, dry and cut into pieces the size of an almond. Peel the onions and slice into Julienne strips.

2. Scald the tomatoes for a few seconds and leave to cool a couple of minutes before removing the skins, quarter, remove the seeds and finely chop.

3. Heat 4 soup spoons of oil in a *greixonera* or earthenware cooking pot and fry the onions, with a pinch of salt, on a low light for 10 minutes. When the onions are well browned, add the chopped meat, slightly raise the heat and sauté together for a few minutes more until the meat is browned.

4. Add the chopped tomato, stir well and lightly fry on an average heat for 15 minutes. Next strain the stock and pour over the meat, leaving the stew to cook for between 1 1/2 to 2 hours depending on the age of the lamb.

5. Once the meat is tender, add the vermicelli. Check the seasoning and rectify the salt and pepper as necessary. Stir well and leave the vermicelli to cook for between 7 to 9 minutes, according to the maker's instructions.

Binissalem comes under the Designation of Origin for wine producing regions, the reason for which the town's most renowned fiestas are those which relate to the grape harvest. This takes place during the month of September, one of the traditions being to relish in this pasta dish made with mutton. In former times it was provided to nourish the grape pickers.

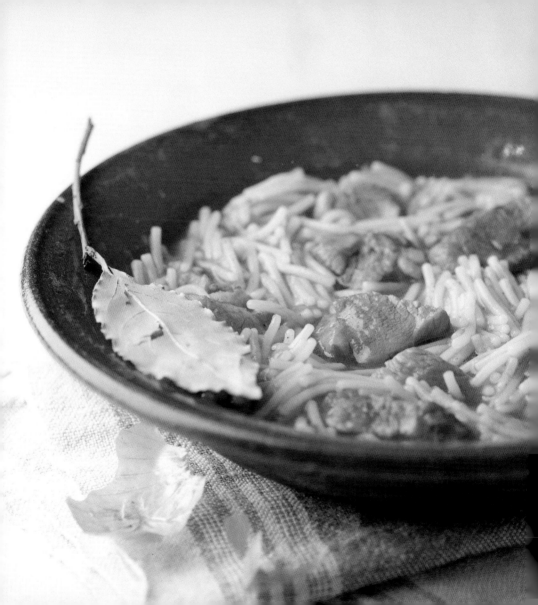

# perdius amb xicra
# stewed partridge

* 4 partridges * 1 thick slice of fresh pancetta * 1 or 2 *botifarró* * 3 cs raisins * 3 cs pine nuts
* 1 large onion * 1 dl Sherry * 6 cs olive oil or lard * salt * ground black pepper

1. Carefully pluck any remaining partridge feathers, which can be done by burning them over a flame. Remove the heads, innards and giblets from the partridges. Wash and season the inside with salt and pepper.

2. Cut both the *botifarró* and the pancetta into 4 pieces, placing a piece of each inside each partridge. Close the opening and secure with a cocktail stick. Peel and very finely chop the onion.

3. Heat the oil or lard in an earthenware cooking pot. The partridges can, if preferred, be browned first on all sides, after which they should be immediately removed with a skimmer and set aside. In this same oil, sauté the onion with a pinch of salt for 5 minutes and once browned drench with the sherry and 1 decilitre of water.

4. Season the partridges on the outside with salt and pepper, place in the pot, reduce the heat to the minimum, cover and cook the stew for 25 minutes. Next add the raisins and pine nuts and cook for a further 15 to 20 minutes.

Check the partridges are cooked by piercing with a rod to see whether or not any juices come out.

In Balearic cuisine, dried fruits such as almonds and pine nuts aren't usually toasted before adding to the recipes. This can be done should you wish to intensify their flavour. In that case, spread the pine nuts in a thin layer over a sheet of brown paper and bake on an oven tray at a medium to high temperature.

# escaldums de pollastre
# chicken escaldums

* 800 g chicken or pullet * 300 g potatoes (small potatoes) * 1 onion * 1 head of garlic
* 50 g de ground un-blanched almonds (ground in a mortar and pestle) * 1 dl brandy
* 2.5 dl water * 1 bay leaf * olive oil * flour * salt * ground black pepper * sprig of fresh *moraduix* (marjoram)

1. Peel the almonds and grind to a fine powder in a mortar and pestle. Peel and finely chop the onion. Peel the potatoes. Wash and drain the *moraduix*. Cut the chicken into eight portions, season with salt and pepper and lightly flour, removing any excess flour.

2. Remove the top layers of dry skin from the head of garlic without separating the cloves. Heat 2 tablespoons of oil in an earthenware cooking pot or *greixonera* and brown the chicken on all sides. Once browned, remove the chicken with a skimmer and set aside. In the same oil soften the onion on a low light together with the garlic head and a pinch of salt.

3. Once the onion has softened add the brandy, water, bay leaf and the chicken. Season, add the sprig of marjoram, cover and cook on a low light for 30 minutes.

4. Lastly brown the potatoes by frying whole in very hot oil and remove with a skimmer to slightly drain the oil before adding to the cooking pot together with the ground almonds. Cook on a low light for a further 10 minutes.

This stew can also be made with pullet and a pinch of cinnamon can be added. The potatoes are a small variety, very popular in Majorcan gastronomy. The *moraduix* is a Majorcan variety of marjoram with a very similar flavour although not exactly the same.

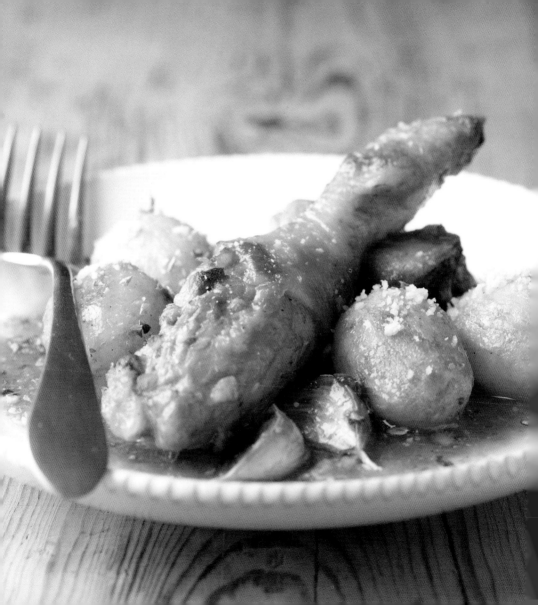

03

Serves four

# desserts

# bunyols de les verges
# virgin's dumplings

* 250 g flour * 500 g potatoes * 15 g fresh baker's yeast * 2 dl water * olive oil to fry * sugar
* salt

1. Peel the potatoes, cut up and cook for 30 minutes in plenty of salted water. Separately, crumble the yeast into a small glass and dissolve in a little tepid water with a pinch of table salt mixing all together with a teaspoon until a smooth lump free paste is obtained.

2. Completely drain the potatoes and leave to cool slightly before pureeing by passing through a hand food mill or mouli-legumes. Once the puree is ready, add the yeast paste and mix well with a wooden spatula.

3. Sieve the flour (or pass through a fine strainer to get rid of any lumps) and gradually add to the potatoes, at the same time blending together to create a smooth sticky mixture.

4. Cover with a cloth and leave the mixture to stand in a warm draught-free place until doubled in size (between 30 and 60 minutes).

5. Using a deep fat fryer, heat up plenty of frying oil or mild olive oil. Roll the mixture into small dumplings with wet hands and brown in the oil.

6. Remove the dumplings with a skimmer and leave to drain for a few minutes on a plate covered with layers of absorbent kitchen paper. Before serving, sprinkle with plenty of sugar.

These dumplings are served to the youths after they have serenaded the young women on the night of the 20th October, eve of the Festival of the Virgins. Dumplings are a typically Mediterranean dessert also popular in countries such as Morocco, Turkey, Greece and Egypt.

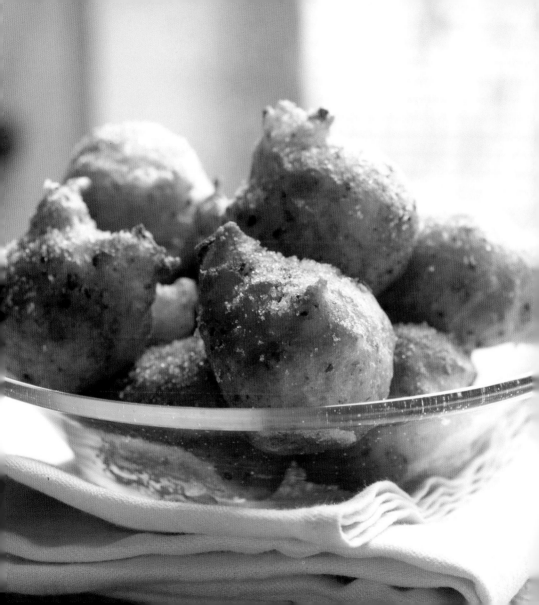

# pomes al forn
# baked apples

4 apples

2 oranges

1 lemon

1. Light and preheat the oven to 180° C. Juice the citrus fruits, strain and mix well. Wash and dry the apples.

2. Remove the apple cores with an apple corer or by cutting a circle around the apple stalk with a knife and pushing down.

3. Place the apples in an oven dish and quickly pour the citric juice over the apple core hole to prevent oxidation.

4. Place on the middle oven shelf and leave to cook for 45 minutes, sprinkling with a little of the orange and lemon juice mix every 15 minutes.

This recipe works well with slightly acidic varieties of apple such as Egremont, Granny Smiths or Canada. The apples cultivated in the Tramuntana mountains, in the north of the island, are known as Orient apples and the mountain climate combined with the altitude and the chalky soils give this apple certain distinguishing characteristics which make it particularly well appreciated.

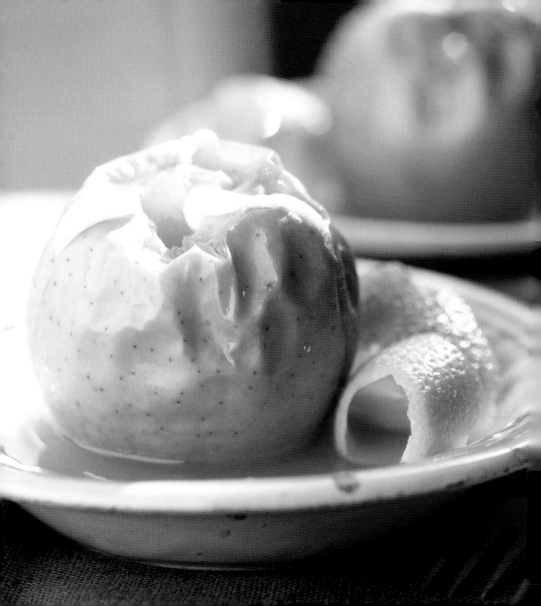

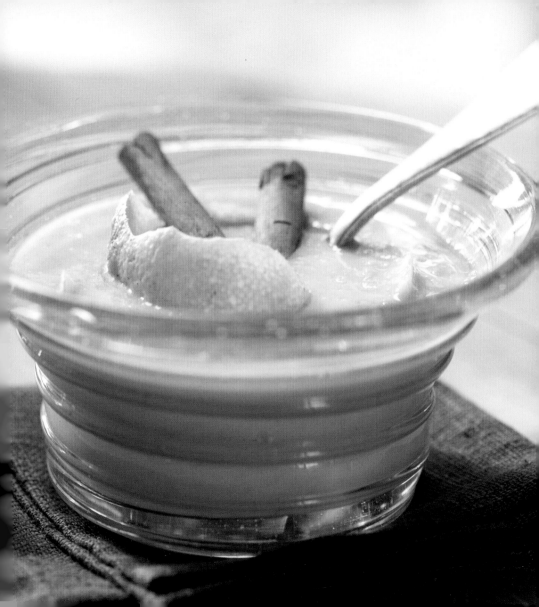

# llet d'ametlla
# almond milk

100 g raw almonds
100 g sugar
1 lemon
1 cinnamon stick

1. Peel the almonds and grind to a fine powder in a mortar and pestle. Wash and dry the lemon and remove half the rind with a knife or vegetable peeler, taking care not to remove the bitter white pith.

2. In a deep saucepan, mix together the ground almonds with the sugar, breaking up any possible lumps by hand. Add 1 1/2 litres of water, the cinnamon stick and the lemon rind.

3. Cook on a high heat until the mix begins to boil. Reduce the heat to the minimum and leave to simmer for 3 hours, adding water as the mixture thickens to acquire the desired texture.

3. Served hot, accompanied by a sweet pastry or white bread, or alternatively chilled in individual dishes as a dessert.

This is a home-made variation of traditional almond milk. The original was made by grinding the almonds between two stone millstones, a task carried out by the nuns in some convents, before it was boiled. Almond milk was used in medieval cooking to elaborate both sweet and savoury dishes such as "blanc mange" (*menjar blanc*).

# llesques de papa
# french toasts

12-16 slices of either very dry cake or Vienna bread rolls

1/2 litre milk

2 eggs

icing sugar

3/4 litre of oil for frying

1. Cut the dry cake into slices 1.5 centimetres thick. Beat the eggs with a fork in a deep dish. Pour the milk into another deep dish.

2. Heat plenty of oil in a deep frying pan or deep fryer without basket. Next to the frying pan, prepare a tray by covering with sheets of absorbent kitchen paper.

3. Quickly dip the cake or bread slices one by one into the milk so as to be soaked but not to the point of breaking up. After leaving to drain slightly, coat both sides with the beaten egg. Next brown both sides in the hot oil.

4. Once fried, leave the French toasts to drain for a few minutes on the tray with the absorbent kitchen paper before sprinkling with plenty of icing sugar.

This recipe serves to make use of any leftover cake or bread rolls as they have to be dried for a few days in order not to break up once soaked in the milk. Some Majorcan bakers sell ready packed slices of *ensaïmada* or dry cake with various culinary applications.

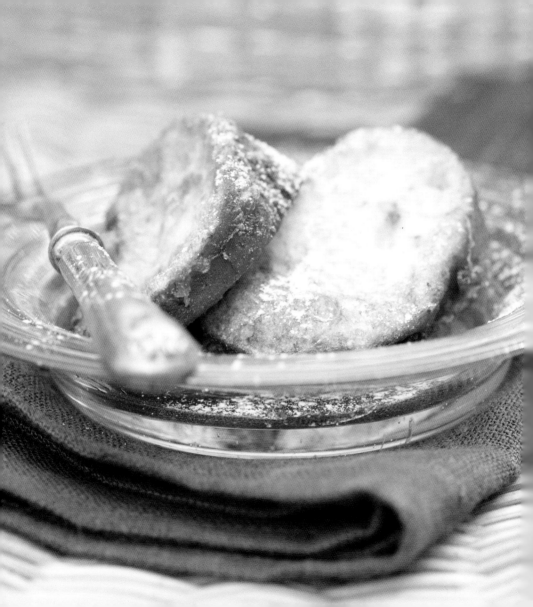

# bunyols de bledes amb mel
# chard dumplings
# with honey

3 or 4 fresh chard leaves
50 g flour
0.75 dl cold water
1 pinch of salt
1/4 litre olive oil
Honey or sugar to taste

1. First the chard must be washed: remove the centre, separate the leaves and wash well in cold water. Next separate the fleshy leaves from the green and cut into fine julienne strips. Put the oven on a medium light and place a covered serving dish in the oven.

2. Next, mix together in a bowl, the flour and salt, breaking up any lumps with the fingers. Add the water little by little whilst mixing at the same time with a spatula or wooden spoon until a smooth white lump free mixture is obtained. Add the chard julienne strips to this mixture and mix well.

3. Heat the oil in a frying pan and individually fry spoonfuls of the mixture, removing from the oil when the dumplings are browned on both sides.

4. Drain the dumplings on a plate covered with sheets of absorbent paper. Remove the dish from the oven and place the dumplings in the dish as they are done. Serve lukewarm with a good dash of honey or a good sprinkling of sugar.

This dessert is a sweet dish from the so called "subsistence" times, as old fashioned and simple as it is surprising. It can also be served as a savoury side dish to accompany meat. Chard is a versatile vegetable, frequently used in the island's gastronomy and which has to be consumed fresh before it loses its vitamins.

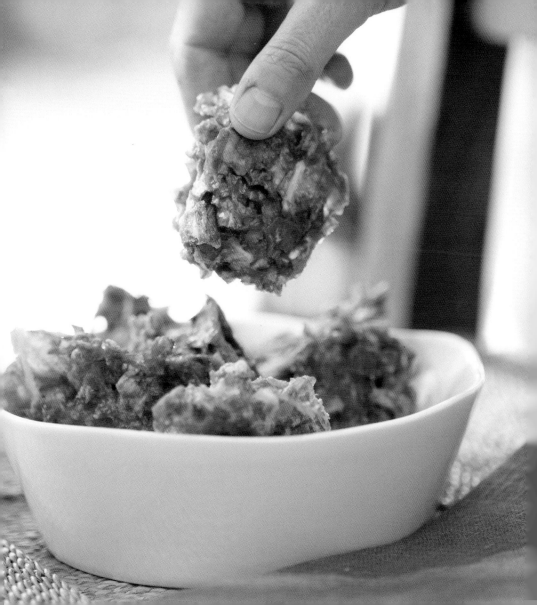

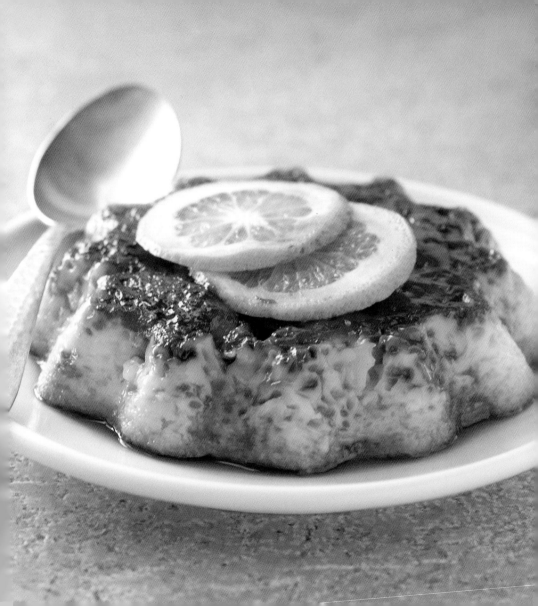

# flam de taronja
# orange flan

250 ml natural orange juice

5 eggs

2 cs lemon juice

200 g sugar

1 cs sugar

1. Carefully measure and weigh all the ingredients. Place a bain-marie with hot water into an oven pre-heated to 150ºC. Juice the oranges and strain the juice to eliminate any possible pips.

2. Put the juice in a bowl with the sugar and mix with a manual whisk, until the sugar has dissolved completely.

3. Crack the eggs and add to the juice whisking very gently so as not to create too much foam.

4. Caramelise the remaining sugar and two spoonfuls of lemon juice by cooking and stirring continuously until a translucent caramel is obtained. Pour the caramel into a flan mould.

5. Top up the mould with the egg and fruit juice mixture, place in the bain-marie and bake in the centre of the oven for 25 to 30 minutes, check if the flan is cooked by piercing the centre of the flan with a rod which should come out clean.

6. Leave the flan to cool at room temperature before removing from the mould and placing on a serving dish.

If very sweet oranges are used, the amount of sugar can be reduced. Majorcan oranges from Soller are well renowned fro their flavour and quality. In blossom time the entire valley is filled with the scent of orange blossom. A veritable delight to the senses.

# codonyat
# quince jelly

1 kg quinces
1 kg sugar
2 lemons
oil

1. Clean the quinces by wiping with a damp cloth. Cut into eight with the skin intact, remove the core and place in a deep pot. Wash, dry and juice the lemons, filter the juice through a fine strainer and save the skins.

2. Cover the pieces of fruit with water and heat the pan until the mixture reaches boiling point. Lower the heat and cook the quinces until soft, testing with a rod or fork. Next, drain and blend the fruit with an electric blender, weigh the puree and note the weight.

3. Place the fruit puree in a saucepan with the weight of amount, the juice and the lemon skins.

4. Simmer on a low light, stirring constantly with a wooden spoon or spatula, until the mixture thickens and comes away from the sides of the pan.

5. Grease the bottom and sides of a mould with absorbent paper and vegetable oil and pour in the quince mixture. Leave to cool down completely at room temperature and to set before eating.

To clean the quinces, which originate from Asia Minor, only the fine downy hair needs to be removed with a cloth. Quinces can also be stewed, as in a compote, making an excellent garnish for meats, especially fowl. The Greeks considered quince to be the symbol of happiness, love and fertility.

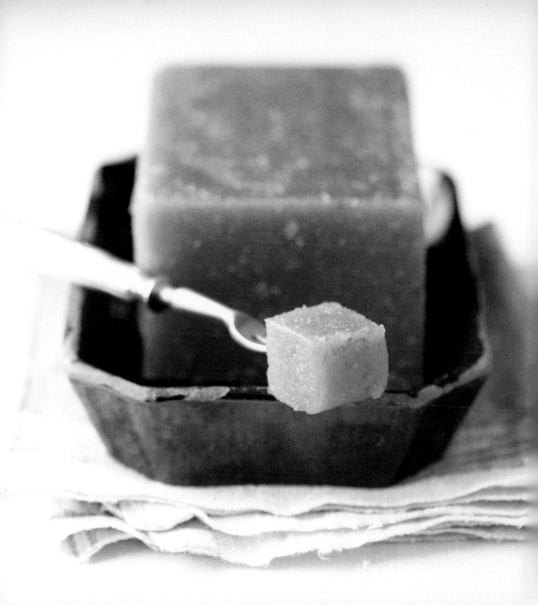

# orellanes
# orellanes

1 egg
2 cs icing sugar
4 cs milk
1 cc lard
flour
oil to fry

1. Firstly, pass plenty of flour through a fine mesh sieve onto a dish. Next break the egg into a deep bowl, add the lard and sugar, finally sprinkling all with the milk. The ingredients must be mixed by hand in order for the lard to melt.

2. Add the flour little by little by passing through a sieve over the bowl. At the same time mix the ingredients until a lump free paste is obtained of an even consistency and soft texture but which easily comes away from the sides of the bowl.

3. Sprinkle flour over the entire work surface and, using a floured rolling pin, roll out the pastry until it is very thin. With the aid of a knife, cut the pastry into small rectangular pieces.

4. Heat plenty of oil in a basket free deep fryer and fry the *orellanes* until golden both sides. Remove from the oil using a skimmer, leave to drain slightly before placing in a serving dish and sprinkle with icing sugar just before serving.

The shape of the *orellanes* varies from one house to another but the most important aspect is the thickness, which has to be very fine. In some towns the pastry mix for the *orellanes* is flavoured with orange rind and even a few drops of anis liquor.

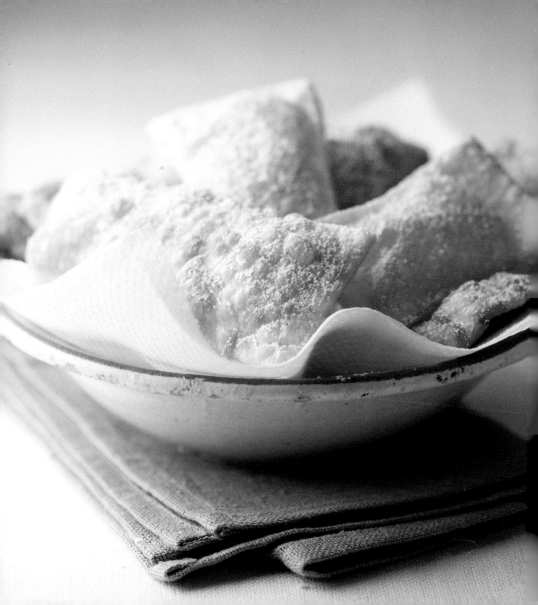

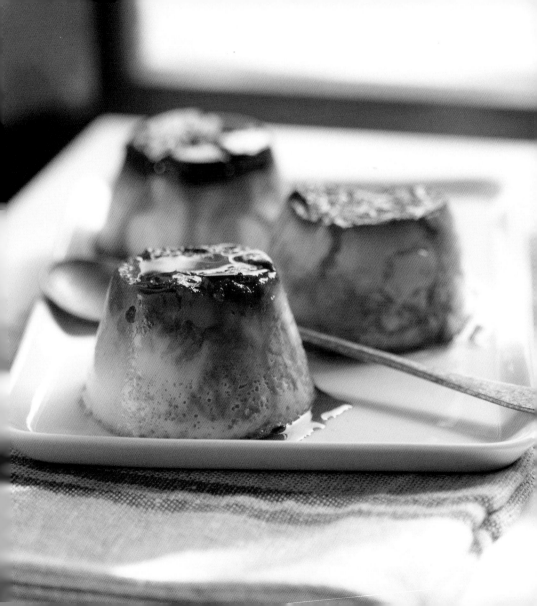

# greixonera d'ensaïmada
# *ensaïmada* flan

2 dry *ensaïmadas* (or bread rolls)

1/2 litre milk

5 eggs

9 cs sugar

1 cinnamon or vanilla stick

1/2 lemon

1. Break up the *ensaïmadas* (or bread rolls in their absence) crumbling into tiny pieces. Wash and dry the lemon and remove the lemon rind using a vegetable peeler, avoiding the bitter white pith.

2. Heat the milk in a saucepan with a piece of the lemon rind, the cinnamon stick and 5 soup spoons of sugar. Bring to the boil and immediately turn off the burner. Remove the lemon rind and the cinnamon.

3. Place a bain-marie in the oven and heat to 150° C. Separate 5 yolks and three egg whites, whisk with a manual whisk to prevent creating too much foam. Mix the eggs with the milk until they form a cream.

4. In a small saucepan caramelise the rest of the sugar by mixing with 1 tablespoon of lemon juice and heating, stirring constantly until a translucent caramel is obtained. Pour the caramel into the mould, place the crumbled *ensaïmada* on top and add the cream, leaving a space of at least one centimetre below the rim.

5. Place the mould in the bain-marie and bake in the oven for 25 minutes, until the surface is lightly browned.

This is a very popular dessert throughout Majorca and always present on restaurant menus, being the best way to make the most of dried *ensaïmada*s and bread. Usually made in pudding moulds, whether individual or 1 litre capacity. Served cold and accompanied by whipped cream.

# greixonera de brossat
# ricotta type cheese
# *greixonera*

1kg ricotta type cheese

200 g sugar

2 dl milk

7 eggs

2 lemons

1 cc ground cinnamon

butter to grease the baking tin or *greixonera* (earthenware oven dish)

1. Preheat the oven to 175° C. grease the inside of the baking tin or *greixonera* with butter. Wash and dry the lemons and finely grate the lemon rind without including the bitter white pith.

2. Drain the ricotta type cheese and put in a deep bowl. Crack and add the eggs, sugar, grated lemon rind, cinnamon and milk. Mix all together well with either a spatula, a wooden spoon, or by hand.

3. Any remaining lumps can be broken between the fingers. Fill the *greixonera* or baking tin with the mixture and bake in the middle of the oven for 40 minutes until the surface is browned.

4. Leave the *greixonera* to cool before serving. Can be served with either jam or fresh fruit jelly as preferred.

A *greixonera* or earthenware oven dish is used for this recipe but if not available a baking tin or flan dish can be used. Recommendations are to use a good quality cheese whether made from cow's or sheep's milk. Either way this is a rich source of calcium.

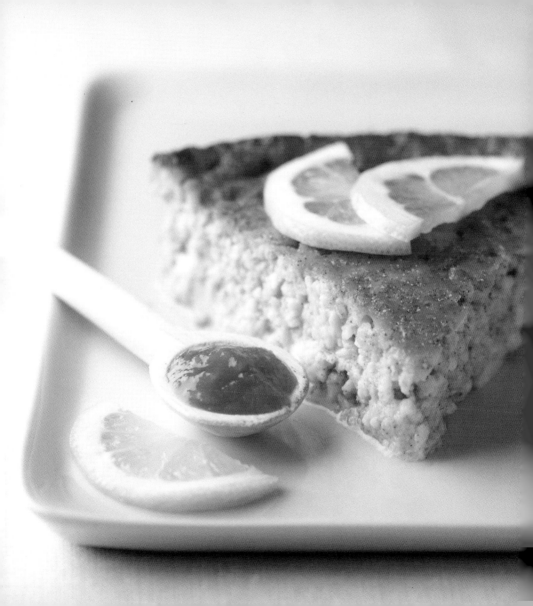

# tambor d'ametlla
# almond drum

250 g raw Marcona almonds
250 g sugar
1 lemon
oil to grease the baking tin

1. Light the oven on a medium heat. Lightly brown the almonds by spreading in a thin layer over the oven shelf covered with either baking paper or grease proof paper.
2. If need be, completely peel the almonds, split down the middle or cut in thick slices lengthways. Grease the sides and bottom of a rectangular baking tin with a cloth or kitchen paper soaked in oil.
3. Cut the lemon in half. Place the sugar in a medium saucepan and heat until it becomes caramelised. Next add the almonds and mix altogether rapidly with a wooden spoon.
4. Pour the almond caramel mixture into the greased baking tin and spread rapidly, pushing and pressing down with the lemon halves until the tin is completely covered.
5. Before it all hardens, the "drum" has to be cut in with a knife, giving it the desired shape, whether rhombus, squares, rectangles or small rectangular bars.

The almond drum is a simple recipe but requires certain dexterity when it comes to making it: both the mixing time for the caramel and almonds as the spreading and subsequent cutting of the pieces or bars has to be done very quickly before the mixture cools and hardens.

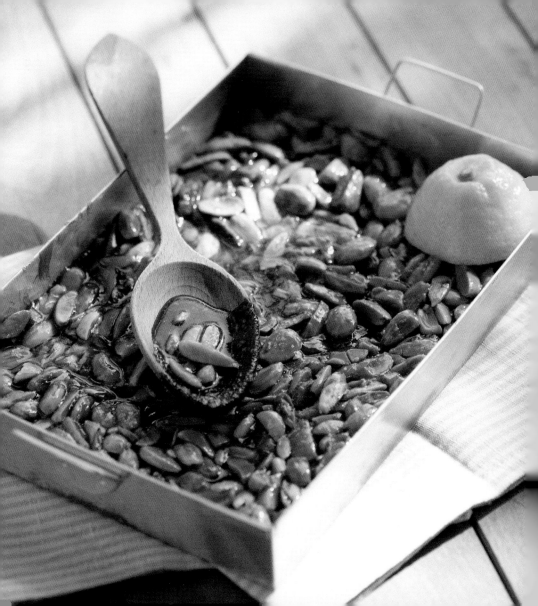

# mantegades d'ametlla
# almond biscuits

200 g raw Marcona almonds
200 g lard
200 g icing sugar
200 g flour

1. Preheat the oven to 180° C. Completely cover a baking tray with baking paper and spread a thin layer of the previously peeled almonds over the tray. Brown the almonds with the baking tray in the centre of the oven, keeping a watchful eye as they burn very easily (should be ready in 7 to 10 minutes, although it can be less).

2. Remove from the oven and leave to cool before grinding to a fine powder in a mortar and pestle. Separately, in a medium sized bowl, mix the flour and sugar, breaking up any lumps with the fingers, and afterwards adding the finely ground almonds.

3. Cut the lard into pieces, add to the mixture and blend together well, using the hands as the heat helps to melt the lard and blend it into the mixture.

4. Lower the oven temperature to 170° C. With floured hands form the mixture into little balls the size of a nut. Spread out, without touching (2-3 cm apart) over the baking paper, slightly flatten with the palm of the hand and bake in the middle of the oven for 30 minutes.

The Marcona almond is the flattest and widest of the island's indigenous varieties. In Majorca it is the one most frequently used in desserts and is sold in various forms, ground, sliced, coated or whole, raw or toasted. Almonds are a very popular ingredient in Majorcan desserts

# vocabulary

**Ametla or ametlla.** Almond.

**Anfós.** Grouper

*Botifarró.* Type of sausage typical of the slaughter, ideal to barbecue, fry or add to stews.

**Brossat.** Ricotta-type cheese

**Camaiot.** Sausage made from pork rind from the leg or neck of the pig.

**Cap-roig.** Red scorpion fish

**cc.** Coffee spoon

**Celler.** Bodega, still known by the same name but mostly converted into restaurants serving traditional dishes.

**Cocarroi.** Traditional small half moon shaped pastry filled with vegetables, raisins and pine nuts.

**Colflori.** Cauliflower

**cs.** Soup spoon

**Escaldums.** Chicken or turkey stew with potatoes.

**Esclata-sang.** Saffron milk cap.

**Frit.** Fried dish which combines lamb or pork giblets with potatoes, vegetables and spices.

**Fonoll marí.** Sea fennel, eaten pickled as an accompaniment to dishes such as pa amb oli.

**Gató.** Traditional almond pastry.

**Granada.** The name of a dish usually based on aubergines.

**Greixonera.** Earthenware cooking pot or dish frequently used in Majorcan cooking. The dish cooked in the pot also receives the same name, *greixonera*.

**Llampuga.** Common dolpinfish, a fish frequently in Majorca, which appears in Balearic waters at the end of summer.

**Llampugueres.** Nets with which the *llampuga* are caught.

**Moraduix.** One of the most commonly used herbs in Majorcan cooking, similar to marjoram.

**Palo.** Liquor typical to the island.

**Pa amb oli.** Bread with tomato, olive oil and salt, eaten with pickles, cured meats or cheese.

**Panada.** Small savoury pasty filled with lamb, peas or fish.

**Patató.** Small potato

**Porc negre.** The black pig, a breed of pig indigenous to the island.

**Porcella.** Suckling pig

**Possessió.** The name given to a rural property in Majorca, in which the centre of production and management is centred on a large house on the farmland.

**Robiol.** Tradional sweet half moon shaped pastry filled with jam, pumpkin in syrup or ricotta type cheese.

**Saïm.** Pork fat or lard, frequently used in Majorcan cooking and from whence comes the name *ensaïmada*.

**Tàpera.** Caper bud

**Taperot.** Caper

**Tomate de ramellet.** A type of tomato frequently used in Majorcan cooking and indispensable for making a good pa amb oli.

**Xulla.** Pork or bacon fat.

# bibliography

**Alcàntara Penya, P.**
Cuina mallorquina. Biblioteca Raixa nº 150. Ed. Moll. Majorca, 1994.

**Bàguena, N.**
De l'antiga Roma a la teva cuina. Edicions El Mèdol. Tarragona, 1997.

**Camba, J.**
La casa de Lúculo o el arte de comer. Sugar R & B. Donosti, 1996.

**Capel, J.C.**
El banquete del mar. R & B Ediciones. Donosti, 1995.

**Capel, J.C.**
El pan nuestro. R & B Ediciones. Donosti, 1997.

**Contreras I Mas, A., Pinya Florit, A.**
La *sobrassada* de Mallorca. Cuina i Cultura. Ed. Consell Insular de Mallorca-Fodesma. Palma, 2000.

**Cunqueiro, A.**
La cocina cristiana de Occidente. Tusquets editores. Col. Los 5 sentidos. Barcelona, 1991.

**Davidson, A.**
La cocina del Mar Mediterráneo. Ed. Omega. Barcelona, 1996.

**Fàbrega, J.**
El llibre de les herbes i les espècies. Edicions de la Magrana. Barcelona, 1998.

**Fàbrega, J.**
El llibre del peix. Edicions de la Magrana. Barcelona, 1996.

**Fàbrega, J.**

La cuina de Mallorca. Edicions de la Magrana. Barcelona, 1999.

**Ferrà Martorell, M.**

L'ahir i l'avui de la cuina mallorquina. Ed. Sa Nostra, Caixa de Balears. Palma de Mallorca, 1992.

**Frontera, B.**

Aplec d'usos de cuina al Pla de Mallorca. Ed. Ingrama S.A. Inca, 1999.

**Luján, N.**

Historia de la gastronomía. Ed. Folio. Barcelona, 1997.

**Millo, L.**

El libro del pescado. R & B Ediciones. Donosti, 1982.

**Revel, J.F.**

Un festín en palabras. Tusquets Editores. Barcelona, 1996.

**Riera, F., Oliver, J. Terrassa, J.**

Peixos de les Balears. Conselleria d'Obres Públiques. Palma de Mallorca, 1995.

**Ripoll, Ll.**

Llibre dels vins, licors i per necessari. Col. Siurell. Ciutat de Mallorca, 1974.

**Serrano, A.**

Les receptes de na Tonina. Ed. Documenta Balear. Menjavents núm. 15. Palma de Mallorca, 1996.

**Toussaint-Samat, M.**

Historia natural y moral de los alimentos. Alianza Editorial. Madrid, 1991.

# Index recipes

in alphabetical order